£8·95

11·01

POSTMODERNISM

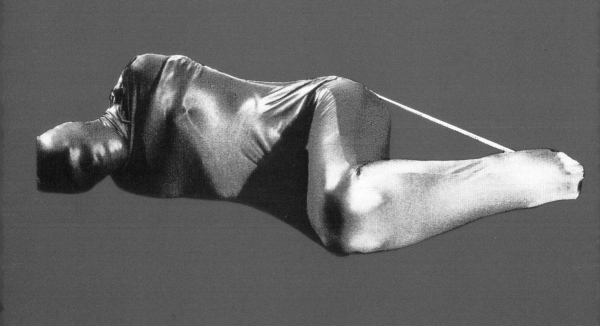

POSTMODERNISM

ELEANOR HEARTNEY

TATE PUBLISHING

Cover:
Gilbert and George,
DEATH 1984 (detail
of fig.46)

Frontispiece:
Sarah Charlesworth
Figures 1983
(detail of fig.41)

ISBN 1 85437 305 6

A catalogue record
for this book is
available from the
British Library

Published by order
of Tate Trustees
by Tate Gallery
Publishing Ltd
Millbank, London
SW1P 4RG

Cover designed by
Slatter-Anderson,
London.
Book designed by
Isambard Thomas

Printed in Hong
Kong by South Sea
International Press
Ltd

Measurements
are given in
centimetres,
height before width,
followed by inches
in brackets

Contents

INTRODUCTION

Like the concept of a God who is everywhere and nowhere, 'postmodernism' is remarkably impervious to definition. A term thrown about to describe phenomena as diverse as the *Star Wars* films, the practice of digital sampling in rock music, television-driven political campaigns and the fashion designs of Jean Paul Gaultier and Issey Miyake, postmodernism seems to permeate contemporary life. And yet, there are few outside the confines of academic departments devoted to Cultural Studies who could confidently say exactly what they think it is.

Part of the difficulty stems from the name. 'Postmodernism', as the term suggests, is unthinkable without modernism. It may be construed as a reaction against the ideals of modernism, as a return to the state that preceded modernism, or even as a continuation and completion of various neglected strains within modernism. But whether the relationship is defined as parasitic, cannibalistic, symbiotic or revolutionary, one thing is clear: you cannot have postmodernism without modernism. Postmodernism is modernism's unruly child. And since the definition of modernism itself remains in dispute, it should come as no surprise that even postmodernism's most ardent advocates seem unable to come to any consensus about what, exactly, it is.

The severity of postmodernism's identity crisis can be glimpsed in some of the terms used to describe it. Characterised variously as 'an incredulity toward metanarratives', 'a crisis of cultural authority' and 'the shift from production to reproduction', and tossed into conversation in the company of words like 'decentred', 'simulation', 'schizophrenic' and 'anti-aesthetic', postmodernism

seems to exist tenuously, as a thing that can only be defined as the negation of something else. To a student of the subject, postmodernism may feel very much like Narcissus' reflection in the water, which disintegrates the moment one reaches out to grasp it.

This, as it turns out, is a very postmodern way to be.

It may be easier to come at the problem by looking more closely at some situations that might be termed 'postmodern'. Take, for instance, the exclusion of the press corps from actual scenes of carnage during the 1991 Gulf War. We were shown instead the footage recorded by the air forces themselves on their targeting equipment. This resulted in a war that played out on the television screen like a video game of surgical strikes on abstract, two-dimensional targets.

In a more bucolic mode, one might point to the founding of a planned community called Celebration outside Orlando, Florida. Touted as an alternative to the crime-ridden cities and suburbs of the United States, Celebration is the creation and bailiwick of the Disney Corporation. Drawing on the mythology of small-town America that underlies Disney's own films and theme parks, Celebration offers a return to a kinder, gentler era – an era that only ever existed on celluloid.

And third, one of the most popular tourist attractions in France is the Lascaux caves, which contain spectacular paintings of hunting scenes from the Palaeolithic era. The fact that the caves themselves have been closed to public view since 1963, and that what is available for view are re-creations of the caves and their paintings in a nearby quarry has done nothing to dim their appeal to the thousands of yearly visitors.

What makes these situations postmodern? Each is characterised by it removal from a reality whose absence is not even felt. Thus, each supports the postmodern tenet that our understanding of the world is based, first and foremost, on mediated images. Each affirms the notion that we live within the sway of a mythology conjured for us by the mass media, movies, advertisements.

With the 'real' world upon which such representations once rested yanked from under us, we find ourselves tumbling down the postmodern rabbit hole. In this strange new world, artworks are reborn as texts, history is exposed as myth, the author dies, reality is repudiated as an outmoded convention, language rules and ideology masquerades as truth.

How did we get into this predicament? And what does it all mean?

From a philosophical point of view, postmodernism is associated with the dethroning of Enlightenment ideas of progress, the independent subject, truth and the external world. The dismal outcome of the utopian ideals that opened the twentieth century have played a big role in undermining such beliefs. So have developments in various scientific fields.

For instance, Einstein's theory of relativity forever exploded the old Newtonian idea of a stable frame of reference, suggesting instead that time and space exist as a continuum and can only be experienced relative to each other. Further undercutting Newtonian certitude, Quantum Mechanics introduced Heisenberg's Uncertainty Principle, which demonstrates that at the atomic level the act of observation alters the object observed. Translated into layman's

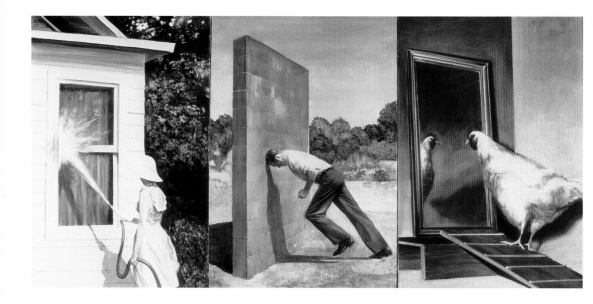

terms, such ideas have infiltrated the culture at large and contributed to a sense of reality's inherent instability. Though they undermined our perceptions of everyday reality, such ideas were still compatible with modernism because they promised to produce facts that everyone could accept as true. But by mid century, even that principle came under fire.

The scientific ideas that probably had the most impact on postmodern theory was the thesis advanced by Thomas Kuhn to explain the evolution of scientific thought. In his groundbreaking book *The Structure of Scientific Revolutions* (1962), Kuhn rejected the conventional idea that science progresses in a rational way, with each new discovery building on and expanding the ideas that preceded it. Instead, he proposed the history of science as a series of ruptures, or 'paradigms', as he called them, which swept away the assumptions of the previous regimes. The illusion of continuity is created by the apparent recurrence of terms or concepts that are revealed on closer examination to have very different and often incompatible meanings from paradigm to paradigm.

Paradigms determine what is thinkable, what constitutes a valid scientific question, what one means by a fact. Thus for instance, the Newtonian idea of gravity as action at a distance was unthinkable in an Aristotelian world where scientific laws were based on movements of matter. Once gravity is understood purely in an instrumental mode, as a reliable mathematical formula, the old questions become simply irrelevant.

Kuhn's thesis remains controversial in the scientific world, where his critics point to the remarkable breakthroughs in all fields of scientific knowledge as refutation of his notion that progress occurs only within paradigms and not between them. But practitioners of disciplines outside science have been much taken with his ideas, and they are frequently invoked by proponents of postmodern theory. For them, the notion of the paradigm neatly encapsulates the idea that truth and knowledge are relative, and depend upon the larger system of assumptions and relations from which they emerge.

This is quite compatible with the linguistic theories of structuralism and poststructuralism, which also began to seep into the larger culture during the 1960s and 1970s. As laid out in Ferdinand de Saussure's *Course in General Linguistics*, originally published in 1916, structuralism conceives of language as a complex system composed of relationships between signs – those elements we ordinarily call words. A sign is itself a relationship between a signifier – the sound or script that makes up a word, and a signified – the meaning of that word.

Construing a sign in this way makes it possible to see the arbitrary nature of language. Notice that no mention has been made in this system of the 'referent' or the 'real', that is, the actual thing in the world, as opposed to the concept and the look or sound of the word. Thus, structuralism questions the commonplace idea that language has a natural connection to things 'out there'. Instead, meaning in language is an internal matter, coming from the interplay between signifiers and signifieds.

A classic illustration of this involves three image and word pairings. The word 'tree' and a picture of the tree might seem to have some natural and constant relationship to each other. But a picture of a door, paired first with the word 'ladies' and then with the word 'gentlemen' makes it clear that the connection between the signified and its signifier is totally dependent on a whole system of cultural understandings, social relationships, and philosophical definitions of gender.

Poststructuralism takes Saussure's ideas further, in effect altogether eliminating the real world, which exists as a shadowy presence in structuralism proper. Now the signified drops out and the meaning of the signifier is simply a matter of its relationship to other signifiers. In poststructuralism, we do not create language from our concrete experience of the world. Rather, it creates us, in the sense that a complex structure of codes, symbols and conventions precedes us and essentially determines what it is possible for us to do and even to think.

Things are further complicated by the fact that meaning exists only in the relationship between signifiers. Thus, it can never be precisely pinned down, as it could when a signifier was tied to a signified. Instead, in poststructuralism, meaning is constantly being deferred. Something will always escape any effort to make a clear and definitive statement. As a result, language is haunted by what is not, or cannot be, said.

Into the interstices of poststructural language comes deconstruction, a very important concept for postmodernism. Deconstruction, as developed in the writings of French philosopher Jacques Derrida, is a way of teasing out the fissures that have opened up within meaning. By reading between the lines, deconstruction reveals that the apparent meaning of the text often masks its opposite. In this, Derrida takes a cue from Freud's notion of repression, in which experiences, memories or feelings are pushed back into the subconscious where they wreak havoc until brought back to the surface.

Deconstruction exposes that which has been suppressed in the name of coherence. It demonstrates that any assertion of truth and any appeal to nature or first principles is a sham. Rather (in a manner reminiscent of the workings

1
Mark Tansey
A Short History of Modernist Painting
1982

Oil on canvas
Three panels, each
147.3 × 121.9
(58 × 48)
Courtesy of Curt
Marcus Gallery,
New York

of Kuhn's paradigm), these are revealed to be the products of a particular system of meaning. In a terminology that will become familiar to readers of this book, they are ideological constructs that attempt to make that which is a product of a particular culture or thought system seem natural and inevitable.

An example may be helpful. Mark Tansey's *A Short History of Modernist Painting* (fig.1) playfully deconstructs the interpretation of modernism that held sway for several decades in the art world at mid-century. As formulated by critic Clement Greenberg (more of whom later), the history of modern art has been a march toward purity in which each discipline – painting, sculpture, music, architecture – slowly shrugs off such extraneous elements as representation, narrative and outside reference so as to be true to its own medium. Tansy has taken the hallowed principles of modernist painting and reduced them to absurdity. The progression from the notion of the painting as a window on the world, to a conception of it as a flat, self-contained surface and, finally, its status as a mirror of the self, are presented as a set of literal anecdotes. No longer necessary and inexorable, they appear here as an arbitrary set of conventions. Tansey adds insult to injury by adopting a dry illustrative technique, which Greenberg believed was long ago superseded by modernist abstraction.

The application of poststructuralist thought to art has some surprising consequences. Most famously it mandates what French theorist Roland Barthes calls 'The Death of the Author' (or, for our purposes, the artist). Barthes' idea can best be understood by recourse to his distinction between the Work and the Text. The Work takes us back to the prestructural realm, where there is a stable external world from which an artwork or piece of writing issues. The reader's job is simply to interpret, or in Barthes' term, 'consume' it, in accordance with the creator's intentions. The Text, by contrast, is composed of that web of interwoven signifiers and deferred meanings that is poststructuralism. Or as Barthes describes it, the Text is 'a multi dimensional space in which a variety of writings, none of them original, blend and clash. The text is a tissue of quotations drawn from the innumerable centres of culture'.

The Text has no author, or at least, no privileged figure who can be lifted above any of the raw materials out of which it is composed. In the end, the Text is created, not by the author, but by the reader who engages with it and puts it to work. Barthes uses the metaphor of music to make his point, likening the Text to a score, which the performer brings to life.

From the conventional viewpoint of art, the death of the author/artist is a grievous blow, because it undermines the whole apparatus of art history, based as it is on notions of signature style and individual genius. It also undercuts the basis of the art market. From a commercial perspective, a work 'in the school of Rembrandt' can never attain the stratospheric prices of an authenticated work by the master himself, no matter how artistically satisfying it might be on all other levels. What is art without an artist? Can the art system continue to function in his or her absence?

Equally strange is the notion of artwork as text. Poststructuralism was initially a theory of literature, so the transition from work to text still kept a book or essay in its original realm of language. But artworks are objects in the

world. They are created from tangible materials and appeal as much to the physical senses of sight and touch as to the mind. How can paintings and sculptures be thought of as 'multidimensional spaces' in Barthes' sense? Must we dispense with the art object altogether and replace it with something more compatible with the requirements of the text? As we shall see, this is the route chosen by certain proponents of postmodernism.

To explain how art could have strayed so far from commonplace ideas about aesthetics and creativity, a brief history of the term 'postmodernism' is now in order. Like the French Revolution, which had multiple starting points, each leading to a more extreme denouement, a variety of starting points have been proposed for postmodernism. The word was used as far back as 1938 by Arnold Toynbee for a new historical cycle that started in 1875 and signalled the end of Western dominance and the decline of individualism, capitalism and Christianity. Interestingly, though he was writing before the period generally thought of as high modernism, Toynbee had already conceptualised many of the characteristics of postmodernism as we think of it today.

2
Philip Johnson
AT&T Building, New York completed 1979

Photograph by Joe Kerr / Architectural Association

'Postmodernism' as a term first entered popular consciousness through architecture in 1979 when Philip Johnson, one of the founders of the austere form of modern architecture known as the International Style, put a Chippendale top on a skyscraper he created for AT&T (fig.2). In this, he was offering a highly visible example of the thesis set out seven years earlier by Robert Venturi in his aptly named *Learning from Las Vegas*. Venturi called for a return to the vernacular forms, historical references and pop imagery that modernist architecture had banished from buildings. Johnson's Chippendale top was ironic and self deflating, putting a cosy domestic gloss on a form of architecture that had grown remote and authoritarian.

In the art world, the idea of postmodernism first began to surface in the 1960s, with the emergence of trends like Pop art, Minimalism, Conceptualism and performance. (In retrospect, nascent examples of postmodernism could be detected much earlier in works by such artists as Duchamp, whose readymades spoofed the preciousness of the art object, late De Chirico, who laid waste to the idea of the uniqueness of the artwork by cannibalising his own work, and even Picasso, whose abrupt stylistic changes made a mockery of the notion of signature style).

Once open for discussion, postmodernism quickly evolved into an assault

on the Greenbergian dogma and its insistence that modernist art constituted an autonomous, self-referential field of human activity. The attacks came from a number of different directions. Pop art revelled in commercial kitsch, wilfully reopening the floodgates to the mass culture and mass taste from which Greenberg thought he had saved high art. Minimalism reintroduced the dreaded 'theatricality', making the viewer a part of the work by requiring him or her to 'activate' the sculpture by moving around it. Conceptual art all but obliterated the optical aspect of the art work so prized by Greenberg while infecting it with the alien element of text. As he watched his fortress besieged on all sides, the high priest of modernism decried the lowering of standards and laid the blame on what he ominously referred to as 'philistine taste', 'middlebrow demands' and 'the democratisation of culture under industrialism'.

There was worse to come: Postminimalism, Body art, Land art, performance, Neo-expressionism, feminism and multiculturalism, to name just a few of the impending horrors. By the 1980s, postmodernism had effected a marriage with poststructuralism, creating for the first time a style that began to characterise itself as postmodern.

During the heyday of postmodernism, artists happily attached their names to the work of other artists and renamed what would once have been termed plagiarism as 'appropriation'. Stuffed bears, plastic bunnies, lava lamps and toilet-bowl cleaners invaded the museum, to be displayed with all the protective security once awarded the Mona Lisa. Hoary forms of academic painting that had been relegated to the dustbin of art history were suddenly à la mode. New rules governed the artistic enterprise. The revolution against the modernist faith in universality, artistic progress, shared meaning and quality was complete.

I

NEO-EXPRESSIONISM

Around 1980, the American art press, which had been prone to dour ruminations on the death of painting, was suddenly galvanised by the emergence of a group of brash young male painters. The newcomers unapologetically disinterred a host of elements that critics of both the pro- and anti-Greenbergian persuasion believed had been buried forever. These included flamboyant brushwork, mythological subjects, nationalistic posturing and premodern stylistic devices. The 'Neo-expressionists' were an international group, hailing from such countries as Germany, Italy, Great Britain and the United States.

The art market had been languishing in the doldrums following redoubled attacks on the art object by those of Conceptual, Postminimal and anti-aesthetic persuasion. With the advent of Neo-expressionism, it perked up, pleased once again that there was something tangible to sell. Younger critics and curators, looking with longing back to the Abstract Expressionist heyday, had despaired of ever having the opportunity to introduce a 'great' art movement or artist to the world. Now they were filled with hope. There was a palpable sense of relief in all quarters. It appeared that the endgame preferred by increasingly radical attacks on the idea of art had been averted. Art history was back on track.

And yet, as critic Arthur Danto pointed out, something seemed awry. Art history, as a narrative of one thing after another, was indeed continuing. But art history as a philosophical enterprise that evolved in accordance with larger historical and cultural forces (and Danto as a practising philosopher was most

interested in such forces) seemed irreconcilable with this new development. He concluded, 'This was not supposed to happen next'. Danto's discomfort stemmed from his sense that art history had changed engines. No longer driven by the profound philosophical questions that he believed underlay the modernist enterprise, art was now fuelled by the far more banal needs of the institutions that had arisen to nurture it. The market needed something to sell. Critics and curators needed something on which to make a reputation. Artists needed something to distinguish themselves from all the others.

Danto's observation led him to formulate a much-discussed idea, namely, that we have reached the end of art. By this, he was referring to art as a

philosophical investigation (his candidate for the end of 'real' art is Andy Warhol's *Brillo Box* of 1964, discussed further in chapter 3). But, unlike others who also sounded a death knell, Danto was upbeat. Art-making continues, he maintained, and in fact, freed from the necessity of philosophical inquiry, has entered into a new realm of pluralism. In the new era, he noted, paraphrasing Dostoyevsky, 'History is dead and everything is permitted'.

Diagnosing the same phenomenon, Marxist theorist Frederic Jameson came up with a bleaker prognosis, outlined in his essay 'Postmodernism and Consumer Society' (1984). For him, the sudden eruption of a new style of painting that borrowed promiscuously from history and mythology was yet

another symptom of a malaise rooted in the emergence of consumer capitalism. This latter is an economic system that obliterates national and psychological borders, undermines social bonds, and fragments the individual psyche, all in the name of turning active citizens into passive consumers. In the cultural sphere, according to Jameson, it has produced a world dominated by the twin conditions of pastiche and schizophrenia.

Jameson's description of pastiche draws on Barthes' notion of the death of the author, and suggests that the ease with which contemporary artists and writers graze over the whole history of Western cultural expression is evidence of their disconnection from any sense of unique selfhood. He gloomily concludes that 'in a world in which stylistic innovation is no longer possible, all that is left is to imitate dead styles, to speak through the masks and with the voices of the styles in the imaginary museum'.

Postmodernism's schizophrenia has a similar source. Jameson is quick to point out that he is not referring to clinical pathology. Rather, taking a cue from the poststructural psychoanalyst Jacques Lacan, he describes schizophrenia as a condition in which 'isolated, disconnected, discontinuous material signifiers ... fail to link up into any coherent sequence'. The result is an experience of the world that occurs solely in the present tense – analogous to the act of repeating the same word over and over until it becomes strange and abstract. The cultural equivalent, Jameson suggested, was the wresting of historical motifs from their original contexts in order to let them float freely through contemporary paintings. Thus, Jameson suggested, Neo-expressionism only appears to be a re-engagement with history and a celebration of individual creativity. In fact, it is rife with pastiche and schizophrenia and capable only of arbitrary ahistoricism and an illusory individualism. Reservations expressed by commentators like Danto and Jameson did little to temper the enthusiasm of the larger art world for Neo-expressionism, though it did kick off widespread debates over the authenticity, originality and sincerity of the artists who fell beneath its rubric. It also inspired a rather nasty contretemps over the question of Neo-expressionism's latent politics.

It did not escape notice that two of the countries in which Neo-expressionism had taken strongest hold were Germany and Italy, leaders of the Axis during the Second World War. In the decades immediately following the war, artists in both countries had resolutely rejected anything that smacked of nationalism, nostalgia, or the insipid academicism that was associated with German and Italian Fascism. By the 1970s, however, a new generation had arrived on the scene. It had no personal involvement in the horrors of the war and felt constricted by the unstated ban on certain kinds of debate.

Arguing that the pursuit of national identity is not the same thing as nationalism, artists began to explore what had been forbidden fruit. Jorg Immendorff was a student of Joseph Beuys, the most influential artist of Germany's post-war era. Seeking a way out of the contradictions of German history and identity, Beuys had turned to performance and installation in an effort to heal the rift between politics and spirituality in the modern psyche. Immendorff shared Beuys' sense of mission, but determined to pursue it through the discredited medium of painting.

3
Jorg Immendorff
We're Coming from
Café Deutschland 1983
Linocut on paper
180.3 x 229.4
(71 × 90¼)
Tate

Immendorff's best-known works are a series of paintings under the title *Café Deutschland*, created during the late 1970s and early 1980s (fig.3). They are set in a cavernous, dimly lit café crammed with figures and symbols from Germany's present and recent past. The artist often appears, passed out on a table, drinking with friends, or otherwise participating in the festivities. Around him swirl the café's other denizens – one may find figures like Erik Honnecker – President of what was then East Germany, fellow artist A.R. Penck and Karl Marx. Ice swastikas attest to a frozen history, a screaming German eagle with

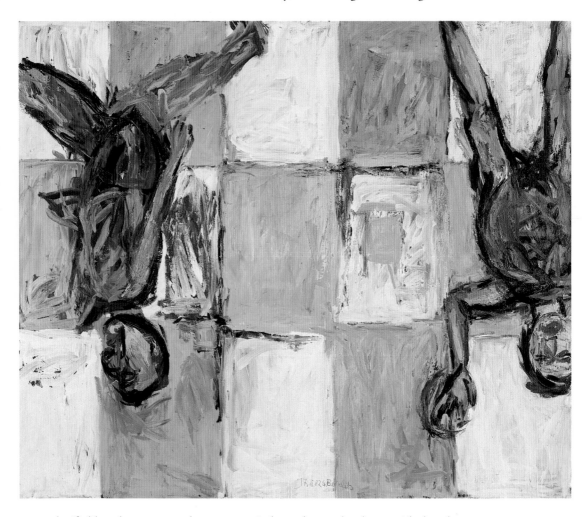

knife-like talons swoops down aggressively, nude couples dance with decadent abandon. The café, whose careening interior suggests a nightmarish cartoon, provides a metaphor for the artist's psyche, rent by an unspeakable history and a brutally divided country.

A similar sense of imbalance dominates the work of Georg Baselitz. A refugee from East Germany in the 1970s, Baselitz remembers watching the firebombing of Dresden as a child. Like Immendorff, he also defied the interdiction against painting, and in the mid-1960s began creating broadly brushed expressionist representations of loutish peasant figures astride ruined

landscapes. Gradually, these figures began to fragment, seeming literally to tear themselves apart on the canvas. Then, in 1969, they flipped upside down, where they have remained ever since.

Baselitz maintains that the inversion of his figures prevents a literal interpretation of the image. Yet, as in *Adieu* (fig.4), it is impossible not to read into the hanging figures the sense of a world that can never be set right. Here, two figures composed of furious slashing brushstrokes seem to be heaving out of the canvas, oblivious to each other's presence. The sense of disconnection is only enhanced by the implacable yellow and white grid that serves as backdrop, untouched by their agitation.

The German Neo-expressionist who has stirred the strongest acclaim and censure is Anselm Kiefer. His ambitious works draw on deep recesses of German romanticism, which had retreated underground in the immediate post-

4
Georg Baselitz

Adieu 1982

Oil on canvas
250 × 300.5
(98½ × 118)
Tate

5
Anselm Kiefer

Parsifal III 1973

Oil and blood on paper
on canvas
300.7 × 434.5
(118¾ × 171)
Tate

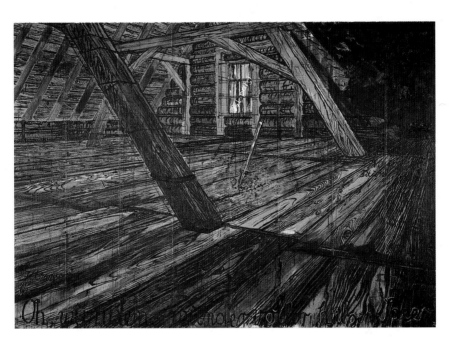

war era. Borrowing from Nordic, Greek, Egyptian, early Christian and Jewish mythology, as well as Teutonic mysticism, he creates works that ambiguously mingle references to German guilt and German idealism. What is Kiefer's stance on Germany's chilling history? Does he hope to rekindle a sense of German identity by vaulting back past the twentieth century to a supposedly purer time?

Kiefer's paintings leave these questions open. The *Parsifal* cycle (1973), for instance, draws on the legend celebrated in one of Wagner's key operas. (Wagner's ties to the Third Reich already make this reference problematic for many commentators.) Parsifal is a reworking of the legend of the Holy Grail. Wagner transforms it into an allegory of the artist/warrior. Emerging in innocence into the world, brought up in ignorance of the chivalric traditions of hunting and war, Parsifal is ordered to recover the spear that will restore peace

to earth. Kiefer's paintings make oblique references to the tale, employing as a setting a wooden attic that doubles as a symbol of the artist's studio and hence his inner world. In *Parsifal III* (fig.5), the sword appears thrust into the floor and the names of the opera's characters, as well as an unsettling reference to the terrorist Baader Meinhof group, can be deciphered within the wood grain. Kiefer's *Parsifal* paintings ask: is the world to be saved by violence or art? Are ignorance and innocence a sufficient bulwark against the evils of the world?

The debate over the new German painting revolves around its political implications. Seeing a dangerous nationalism at work, the German-born Marxist critic Benjamin Buchloh cites parallels between this new work and the reactionary turn of avant-gardist artists of the 1920s and 1930s as they embraced authoritarian regimes in Italy, Germany, the Soviet Union and Spain. Buchloh suggests that the quest for national identity in the work of German and Italian Neo-expressionists is in fact an unhealthy flirtation with the Fascist elements of their countries' recent pasts.

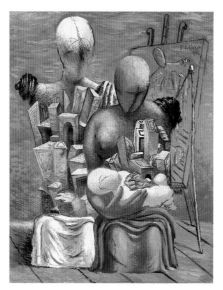

6
Giorgio de Chirico

The Painter's Family
1926

Oil on canvas
146.4 × 114.9
(57¾ × 45¼)
Tate

7
Carlo Maria Mariani

Offspring of Helios
1982

Lithograph on paper
62.2 × 87 (24½ × 34¼)
Tate

8
Sandro Chia

Water Bearer 1981

Oil and pastel on canvas
206.5 × 170
(79 × 98¾)
Tate

American critic Donald Kuspit disputes these arguments, maintaining instead that artists like Kiefer and Immendorff dredge up these nightmares in order to purge them. The German painters, he argues, 'perform an extraordinary service for the German people. They lay to rest the ghosts – profound as only the monstrous can be – of German style, culture and history, so that the people can be authentically new'.

In the Italian version of Neo-expressionism, similar dynamics are at work. Here, the artists are looking back to Italian painting of the 1920s and 1930s, a period derided by high modernists as decadent and aesthetically inferior. Of particular interest to them is Giorgio de Chirico, whose metaphysical painting, filled with mannequins, classical motifs, and a dream-like remove from the realities of political life, stood in such sharp contrast to the forward thrust of official modernism (fig.6). To make matters more delicious, De Chirico's late work turned cannibalistic, as he endlessly recopied his own earlier productions. It was a strategy that the later generation would hail as an anticipation of their own questions about originality and authorship.

The most archly historicist of the Italian Neo-expressionists is Carlo Maria

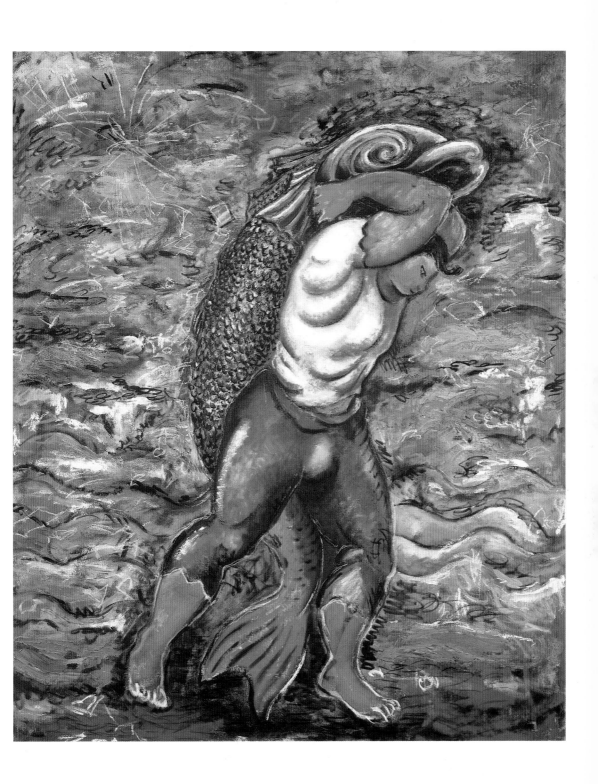

Mariani. He explains his attraction to the past as a revulsion against a contemporary world in which we 'seem to have lost our sense of values'. His work is a remarkably convincing recreation of the neoclassical style, which reigned in Europe at the turn of the eighteenth century. Often there are contemporary references – portraits of artist friends and associates, but they are reimagined as classical heroes or gods. Mariani's ongoing theme seems to be the retreat through art to a timeless realm of beauty and perfection, suggested in *Offspring of Helias* (fig.7), for example, as a reworking of myth of the sisters of Phaethon in which a pair of beautiful nymphs are transformed into trees.

There is an irony, perhaps intended, perhaps not, in Mariani's choice of style. The neoclassical period was itself an emulation of the imagined ideals of

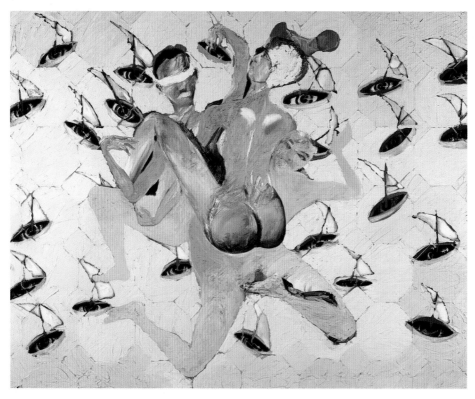

9
Francesco Clemente

Midnight Sun II 1982

Oil on canvas
201 × 250.7
(79 × 98 ¾)
Tate

10
Julian Schnabel

Humanity Asleep 1982

Mixed media on
wooden support
274.3 × 365.6 × 28
(108 × 144 × 11)
Tate

ancient Greece and Rome, and as such, was a favourite reference for the imperial ambitions of the Italian Fascist and Nazi regimes.

De Chirico is an especially important influence on Sandro Chia, whose work transforms images drawn from sources such as classical sculpture and Italian Futurism into tableaux edged with absurdity. Chia's work has been described as an anti-classical classicism, in that it seems to spoof the classical prototypes that Mariani takes more seriously. Chia's protagonists are muscular young men in the mode of the neoclassical hero, but when they are clothed, they are in peasant garb and they convey a sense of vacuous naiveté that is not in keeping with the heroic ideal. Often, they are in transit, though the purpose of the journeys are unclear. In his *Water Bearer* (fig.8) the title suggests a mission, yet the young man struggles not with a water-filled vessel but with a giant fish.

Chia suggests an interpretation when he remarks: 'The fish is a symbol of death … It is the biggest thing we carry around with us.'

The flight from the modern world takes a different form in the work of Francesco Clemente. Rather than escaping into an idealised past (made simpler for the Italian Neo-expressionists by the existence of an almost overwhelming artistic heritage), Clemente has turned inward. He mixes Western traditions with Eastern ones – especially from Hindu art and philosophy – to create works that suggest the experience of the world as an extension of the self. Whilst Clemente employs motifs from sources as diverse as Christianity, tarot, alchemy and astrology, his recurring theme is his own signature face and body,

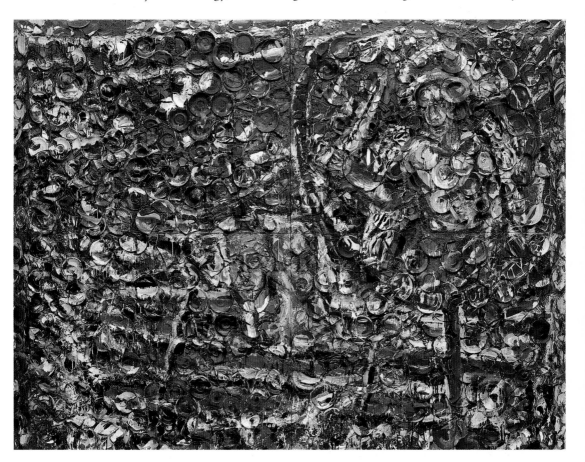

often with an emphasis on bodily orifices. Much of the work expresses an androgynous, auto-erotic and polymorphous sexuality, which draws on his interest in Tantric yoga.

Midnight Sun II (fig.9), for instance, is filled with multilayered symbols that speak of a kind of spiritual transcendence through sex. Three entwined figures, one of them blindfolded, are surrounded by a sea of eyes that also have vaginal overtones. These may make reference to a Hindu legend of the God Indra, who was punished for a sexual indiscretion by having his body covered with marks of the yoni, or vagina, which were later transformed into eyes. But here they are each topped with a small sail. As the small vessels set off for parts unknown,

they seem to partake of a form of a sexually inspired knowledge emanating from the central figures.

American art historian Irving Sandler has chronicled how Neo-expressionism was initially presented by its advocates in Europe as a counter to American hegemony in international culture and economics. Italian and German Neo-expressionism, in particular, were posited as a return to humanism and the venerable artistic traditions that the Americans had all but obliterated with their McDonaldisation of commerce, culture and media. But by the time the German and Italian Neo-expressionists burst onto the American scene, they found they had to contend with a home-grown variation.

In the United States, the emergence of Neo-expressionism coincided with the onset of the Reagan era, and the two phenomena were often linked in critical discourse. For its supporters, the new movement spoke to a hunger for feeling after twenty years of carefully cultivated irony and aesthetic distance. But detractors suggested that the Neo-expressionists were bourgeois rebels, cultivating an aura of raw feeling and unbridled expression while looking over their shoulders at the newly invigorated art market, which was eager to snap up their works.

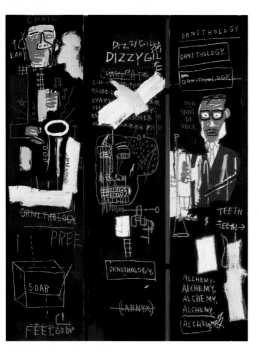

The artist who received the largest brunt of such attacks was Julian Schnabel, a native Texan whose outsize personality and penchant for self-mythification made him the general public's symbol for Neo-expressionism. Styling himself as a man of enormous appetites, he once posed as Tennessee Williams' ultra macho Stanley Kowolski in a photo spread for *Vanity Fair* magazine.

Schnabel took on weighty themes in his work, among them life and death, earthly suffering and spiritual transcendence. He went so far as to title one painting *Portrait of God* (1981). In another, a self-portrait entitled *Saint Sebastian – Born in 1951* (1979), he hinted that he was a martyr for art. His materials were unorthodox too: he scrawled text and loose imagery over black velvet, pony hide, raw tarpaulin and *Kabuki* theatre backdrops.

But Schnabel remains best known for paintings on fields of broken crockery. Drawing the brush over these pseudo-archeological surfaces, he was able to pit image and material against each other in an equal competition. The crockery served a dual purpose. On one hand it made art-historical references to Antonio Gaudí's expressionist architecture and to Byzantine mosaics. But also, thanks to the banality of the mass-market plates and teapots that served as raw

11
Jean-Michel Basquiat
Horn Players 1983
Acrylic and mixed media on canvas
243.8 × 190.5
(96 × 75)
The Broad Art Foundation

12
Eric Fischl
Bad Boy 1981
Oil on canvas
167.6 × 243.8
(66 × 96)
Daros Collection, Switzerland. Courtesy of Mary Boone Gallery, New York

material, it introduced a satisfyingly postmodern element of kitsch. In *Humanity Asleep* (fig.10), Schnabel uses broken plates as the ground for a typically grandiose theme: the artist's fight for understanding in an uncaring world. Hard to make out over the shards are images of a pair of heads, one a self portrait, the other belonging to the artist's friend Francesco Clemente, clinging to a raft. Rising protectively above them is an angel with a sword encircled by a halo/mirror, suggesting that the artist's best tool is his own self-reflection.

Neo-expressionist mythmaking also extended to the career of Jean-Michel Basquiat, a young man of mixed black and hispanic heritage. Basquiat first appeared on the scene in the guise of SAMO, a streetwise graffiti artist whose

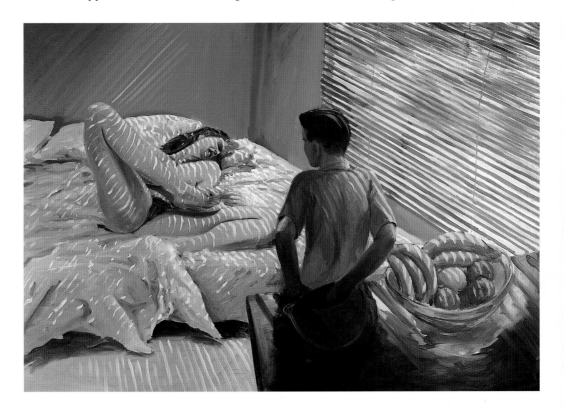

tags betrayed an astute understanding of politics and the art world. Absorbed into the art world and using his own name, he became celebrated as an authentic voice of the street. His paintings blended artfully scrawled texts and cartoonish imagery, which made reference to jazz, sports, Harlem renaissance literature, racism and other elements of the black experience in America. *Horn Players* (fig.11), which pays tribute to the jazz musicians Charlie Parker and Dizzy Gillespie, is a jazzy mix of graffiti-like imagery and texts that reference these masters' music, their places in history and the effect of jazz on the human body.

Contrary to his public image, however, Basquiat was the product of a solid middle-class upbringing. This set him apart from the other, less sophisticated graffiti artists who were also briefly taken up by collectors and art

cognoscenti as the Reagan era's version of 'radical chic'. Nevertheless, Basquiat cultivated his 'wild child' persona, and when he died of a drug overdose in 1988 aged twenty-seven, he was quickly proclaimed a martyr to art and a victim of the overheated hype machine of the 1980s art world in America.

Not all the American Neo-expressionists were so overt in their embrace of the 1980s cult of personality. Eric Fischl took a more circumspect attitude towards the Reagan era's strange combination of free-market economics and social conservatism, although in the height of the market frenzy over Neo-expressionism, any critical overtones in his work did not prevent them from selling extremely readily. Fischl's chosen subject during this period was the undertone of corruption and decadence in the upper-middle-class suburban lifestyle that exemplified the American Dream. Lifting the curtain, he relayed hints of incest, paedophilia, rape and other sexual perversities taking place in suburban living rooms, bedrooms and even outside beside the Olympic-size pool. *Bad Boy* (fig.12) is particularly pointed in its demolition of the Reagan-era devotion to family values. An adolescent boy sits in a suburban bedroom watching a naked woman – presumably his mother – writhe in post-coital satisfaction as the afternoon light breaks through the slats in the Venetian blind. Fischl suggests a double transgression. One involves sexual voyeurism with overtones of incest. The other is a theft scenario as the boy's hands dip into the woman's handbag behind his back. (The analogy between the woman's vagina and purse have been duly noted by critics of a psychoanalytic bent.)

Meanwhile, Neo-expressionism also flowered in Great Britain. Figurative art had never really disappeared there, as it had in the United States and the rest of Europe. In fact, figurative artists such as Francis Bacon, Lucian Freud and R.B. Kitaj remained among the most celebrated in England at a time when painting was being daily decreed dead in other art circles.

As a result, British Neo-expressionism could be seen as part of a continuing tradition rather than a reactionary return. Christopher Le Brun's dreamlike images emerge out of a welter of Abstract Expressionist-type brushstrokes. The white horse is a recurring image, replete with associations from legend and folk tales of purity and truth. In *Dream, Think, Speak* (fig.13), we are presented with a pair of horses, one full-bodied and emerging from what might be a dark lake flanked by shadowy tree forms. The other is partial, a severed ghost-like head appears off to the side. Le Brun feels a kinship with visionary British painters like Turner and William Blake, but is equally connected to the modernist tradition. He sees no contradiction between abstraction and figuration, noting that his images evolve during the painting process like half-forgotten memories tossed up by the subconscious. The title of the work comes from the journal of Delacroix and suggests the way in which painting itself materialises.

Scottish artist Steven Campbell takes a much more self-conscious approach. He cobbles his paintings together from the materials at hand, scattering them with literary and historical references that serve as clues for the viewer to decipher. *The Dangerous Early and Late Life of Lytton Strachey* (fig.14), is crammed with symbols and images relating to the hypocrisies of the Victorian era.

13
Christopher Le Brun

Dream, Think, Speak
1981

Oil on canvas
244 × 228.5 (96 × 90)
Tate

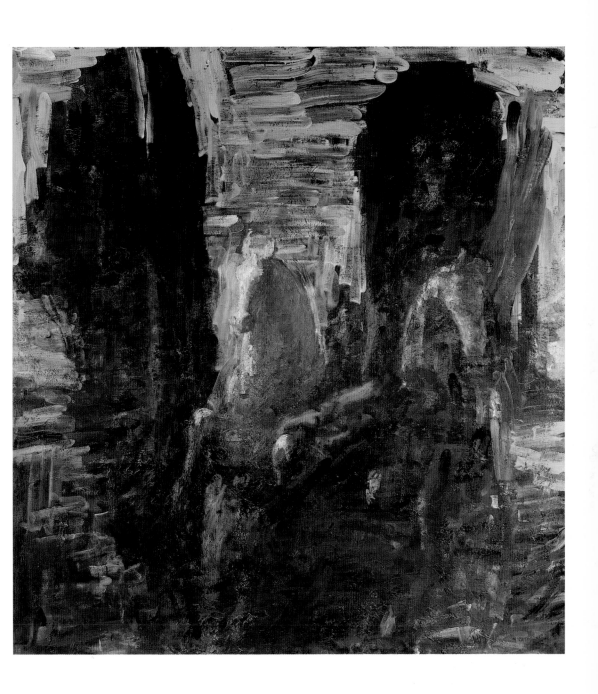

Campbell's eponymous hero, the biographer and chronicler of late Victorian mores, is depicted at three stages of life – as a baby in a cabbage, as a young boy and as a mature adult. The latter two are attached to targets (located on the boy's cap and in the man's arms), suggesting that, in exposing the sexual and political peccadillos of others, Strachey makes himself vulnerable to similar attack. The wallpaper pattern of pansies with human faces make humorous reference to Strachey's own sexual orientation, while other images refer to various subjects of his biographies.

Campbell has a fondness for the art of British illustration, and for English humorists such as Edward Lear and P.G. Wodehouse. His work reflects a

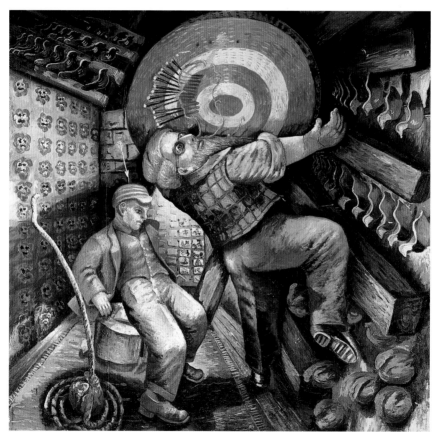

14
Steven Campbell

The Dangerous Early and Late Life of Lytton Strachey 1985

Oil on canvas
261.8 × 274.5
(103 × 108)
Tate

playful sensibility that is light years away from the weighty symbolism of German versions of Neo-expressionism.

As we have seen, Neo-expressionism unfolded differently in different native grounds, suggesting that the notion of national culture might still have some validity. The more radical postmodern position, which we will investigate next, derides any such notion as hopelessly nostalgic.

2

THE ANTI-AESTHETES

Neo-expressionism was seen as frivolously collaborationist by the austere group of postmodernists who rallied around the banner of the 'anti-aesthetic'. With a few notable exceptions, they rejected painting as hopelessly corrupted by its historic dependence on the art market and the mythology of heroic individualism. Moving instead, as the critic Hal Foster put it, 'from production to reproduction', they embraced text, photography and film as the proper tools for a late twentieth-century art. Through these they could explore the one legitimate subject left for art in the wake of the death of modernism. This was representation – a postmodern buzzword that referred to the influx of media and marketing messages out of which, these self-styled Jeremiahs proclaimed, our illusory senses of self and reality are composed.

Scornfully deriding pluralist definitions of postmodernism implicit in the analysis of writers like Danto and Jameson, they issued a call for 'a postmodernism of resistance'. Their mandate was to deconstruct the insidious representations that have depoliticised the citizenry by making oppressive ideological positions seem natural and hence incontestable. In this, they adopted the critique of Roland Barthes, who gave the name 'myth' to this fallacy, describing it thus: '[Myth] ... organises a world which is without contradictions because it is without depth, a world wide open and wallowing in the evident, it establishes a blissful clarity: things appear to mean something by themselves.'

Clarity being the enemy of postmodern resistance, the anti-aesthetes married poststructuralism to postmodernism in order to unearth the

contradictions hidden in ideological constructs. The first order of the day was to convert the art object into text, in order to make it amenable to deconstruction. This had already been partly accomplished by the Conceptual art movement, which, by the late 1960s, had begun to move from the realm of objects to the realm of ideas. Joseph Kosuth, one of the leaders of that movement, insisted that artworks were actually analytical propositions. In *Clock* (fig.15), he demonstrates how this works. *Clock* consists of three elements: a real clock, a photo of the same clock printed actual size, and three blown-up entries from an English–Latin dictionary for the words 'time', 'machination' and 'object'. Which, Kosuth asks, is the real essence of the clock – the mechanical object, its visual representation, or the web of ideas that give it meaning? Thus the artwork itself poses a philosophical question about the meaning of meaning.

In some hands, Conceptual art dropped the object altogether. Lawrence Weiner presented 'artworks' that were simply strings of text to be painted on the wall. These typically described in words the kind of things and

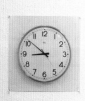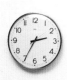

relationships conventionally found in art galleries. In a work like *MANY COLORED OBJECTS PLACED SIDE BY SIDE TO FORM A ROW OF MANY COLORED OBJECTS* (fig.16), he suggests that a linguistic description is equivalent to a material object.

The critical postmodernists found such precedents useful, but felt that Conceptualism was too narrowly focused on art. They wished to expand linguistic analysis to the world at large. Thus, when a younger artist like Jenny Holzer adopted a purely textual approach to art, she cast a much wider net. She directed her attention to the contradictory messages conveyed to the general public from the worlds of politics, advertising and popular culture and she made her field of play the city street rather than the art gallery.

From the mid-1970s, Holzer began turning out series of propositions printed on coloured grounds to be fly-posted on urban walls. The statements had the authoritative tone of public-service announcements, but they offered provocatively ambiguous and contradictory sentiments. Her *Truisms* were statements like 'ABUSE OF POWER SHOULD COME AS NO SURPRISE', which often had the ring of truth until one examined them more closely.

Holzer followed these with the *Inflammatory Essays* (fig.17), whose statements seem to be culled from both the far right and far left of the political spectrum. They exhort readers with such overheated rhetoric as: 'REJOICE! OUR TIMES ARE INTOLERABLE', and 'THE APOCALYPSE WILL BLOSSOM'. Again they were fly-posted on walls and buildings throughout downtown Manhattan.

True to Barthes' injunction against authorship, such works refused to relay the artist's real beliefs. Instead, the Truisms and the Inflammatory Essays seemed to offer a literal demonstration of Barthes' notion of the artwork/text as 'a tissue of quotations drawn from innumerable centres of culture'. In the process, they suggest the emptiness at the core of most political rhetoric.

While many of the most strident anti-aesthetes unequivocally rejected painting as a medium for critical discourse, a small faction suggested that its ties to discredited notions of authenticity and originality made it the perfect vehicle for the final interment of modernism. In a much-discussed essay entitled 'Last Exit: Painting' (1981), critic and painter Thomas Lawson argued that 'The appropriation of painting as a subversive method allows one to place critical aesthetic activity at the centre of the marketplace, where it can cause the most trouble'.

Some of the most effective of these 'subversive' attacks came from Germany, where the heroic romanticism of Neo-expressionism was particularly fevered. Gerhard Richter and Sigmar Polke, both students of Beuys and both born in East Germany (a biographical fact that gave them a certain outsider status in the still divided Germany), lay siege to the idea of individual style and personal expression.

Polke's work undermines the idea of artistic coherence. He mixes multiple styles and modes of representation within each work to create a kind of visual static in which potential meanings cancel each other out. He began employing ben-day dots – the pattern of dots used in commercial four-colour printing – only a few months after they were adopted by Pop artist Roy Lichtenstein, for whom they quickly became a signature style. In Polke's hands, however, the effect was quite different. The dots formed screens that, when printed slightly off-register, served to obscure and partially obliterate the images they were supposed to convey. Later, Polke began to use other mechanical devices to camouflage his images – painting them over preprinted fabric, overlaying thin wire meshes, coating them with splashes of translucent resin, or as in *Figure with Hand* (fig.18), laying them over a grid of nonsense letters and covering the whole with a snakeskin dot pattern.

The conceptual connections between the partially visible images in Polke's work are also obscure. Drawn from mass-produced sources like advertisements, news photos, children's book illustrations and nineteenth-century engravings,

15
Joseph Kosuth

Clock (One and Five)
English/Latin Version
1965

Clock, photograph and printed texts
61 × 290.2
(24 × 114¼)
Tate

16
Lawrence Weiner

MANY COLORED
OBJECTS PLACED SIDE
BY SIDE TO FORM A
ROW OF MANY
COLORED OBJECTS
1979

Anton and Annick
Herbert, Belgium

they jostle together in a way that simultaneously encourages and undermines the viewer's efforts to create meaningful associations.

Gerhard Richter denies coherence in another way. Internally, each work manifests a single approach, but from one work to another, Richter displays radically different styles. Taken as a whole, his oeuvre throws the whole question of artistic expression into disarray. For instance, he creates abstract paintings that make a cliché of their expressiveness. An apparently spontaneous gestural work like *Abstract Painting No.439* (fig.19) is in fact an enlargement of a small sketch that has been projected on the canvas. But while the sketch (fig.20) has the raw edges of an unrehearsed brushstroke, in the painting, Richter has tipped his hand by carefully softening and blurring the 'expressive' marks.

If Richter's abstract paintings have a mechanical quality, his photobased works are deliberately 'painterly' and abstract. *Elizabeth I* (fig.21) is based on a news photograph of Queen Elizabeth, but it has been painted as a soft blur, so that the image almost disappears on close viewing. Richter notes that he likes to use images from the mass media because they liberate him from personal experience. However, he turns the tables on conventional expectations. Richter's media-based works, rather than his expressionist abstractions, have a gently romantic, hand-crafted look.

Not surprisingly, the American version of anti-painting painting took a different turn. It took its cue on one hand from the slickness of American advertising, and on the other from an icy irony that is the flip side of American sentimentality. These qualities were particularly striking in the work of Robert Longo, which presented images of masculinity and authority in forms that evoked the monolithic power of corporate America. Echoing Lawson, he noted that the disrepute of traditional art media made it seem 'really radical to draw, to paint'. He first gained attention with a series of huge, photographically precise black and white drawings of corporate-type men and women. They twist in contorted poses that suggest both recoil from a bullet and the steps of an anguished dance (fig.22). In their expensive suits, the frozen figures speak of the corporate wars that redirect instinctive survival drives toward the brutal competition of the marketplace.

Later, Longo began to produce multipart artworks that mixed painting and

DON'T TALK DOWN TO ME. DON'T BE POLITE TO ME. DON'T TRY TO MAKE ME FEEL NICE. DON'T RELAX. I'LL CUT THE SMILE OFF YOUR FACE. YOU THINK I DON'T KNOW WHAT'S GOING ON. YOU THINK I'M AFRAID TO REACT. THE JOKE'S ON YOU. I'M BIDING MY TIME, LOOKING FOR THE SPOT. YOU THINK NO ONE CAN REACH YOU, NO ONE CAN HAVE WHAT YOU HAVE. I'VE BEEN PLANNING WHILE YOU'RE PLAYING. I'VE BEEN SAVING WHILE YOU'RE SPENDING. THE GAME IS ALMOST OVER SO IT'S TIME YOU ACKNOWLEDGE ME. DO YOU WANT TO FALL NOT EVER KNOWING WHO TOOK YOU?

17
Jenny Holzer

from *Inflammatory Essays* 1979–82

Lithograph on paper
43.1 × 43.1
(17 × 17)
Tate

18
Sigmar Polke

Figure with Hand (I Am Made Dizzy by a Carpet of Rose Petals ...) 1973

Offset lithograph on paper 62.6 × 45.3
(24⅝ × 17⅞)
Tate

19
Gerhard Richter

Abstract Painting No.439 1978

Oil on canvas
200 × 300
(78¾ × 118)
Tate

20
Gerhard Richter

Oil Sketch No.432/11 1977

Oil on canvas
52.4 × 78.4
(20¾ × 31)
Tate

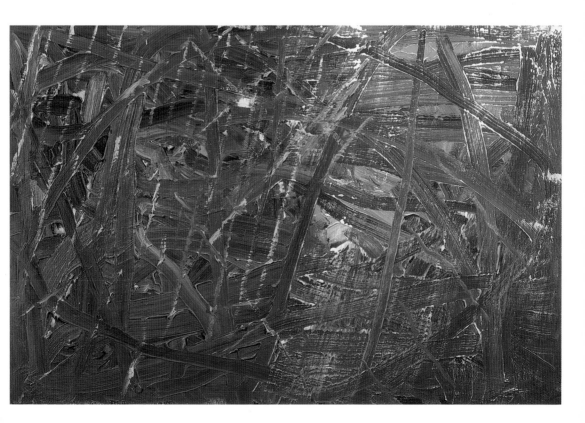

drawing with aluminium and fibreglass constructions. They take the idea of urban dehumanisation even further, graphically squeezing the human body beneath or between emblems of corporate or military might. *Sword of the Pig* (fig.23) is a coldly impersonal meditation on masculinity. Sword-like in overall shape, each of its individual elements makes reference to stereotypes of

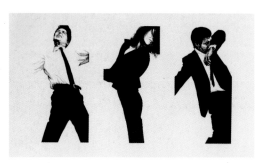

machismo. The sword hilt is an abstracted church tower, turned on its side but flagrantly phallic nevertheless. The centre section is a painting of the wildly muscular torso of a body builder, which is attached to the final section, the scabbard of the sword. This latter is a reworking of a news photograph of abandoned missile silos in the American Midwest, their upright forms completing the transcription of the male body into military weaponry. Longo notes that the 'pig' of the title is derived from the popular epithet for the overly macho man. 'Pig' is also a derogatory term for the police and in fact the upper torso of the figure is based on a photograph of a New York City policeman.

A different order of coldness permeates David Salle's paintings. Often grouped with the American Neo-expressionists because of his predilection for painting, Salle is in fact their polar opposite. His paintings deliberately suppress any hint of self expression, going so far as to suggest that different sections, composed in different styles, come from different hands. (And in fact Salle hires assistants to paint some sections of his paintings.) The imagery is equally cool, drawn from popular media, soft-core pornography, modern-style home interiors, art history and kitsch. Images are juxtaposed and overlaid in ways that hint at associative meaning without ever delivering it. Commentators have linked Salle's approach with that of Pop artist James Rosenquist, who also assembles fragmentary compositions from slightly out-of-date commercial and media imagery (fig.24). But while Rosenquist employs the hot seductive colours of advertising billboards to evoke the mass media's manipulation of desire, Salle deliberately flattens his palette. Much of the canvas is painted in black and white, and the occasional flashes of brilliant colour are neutralised by sickly shades of yellow and green and greyed-out blue.

21
Gerhard Richter

Elizabeth I 1966

Offset lithograph on paper
70 × 59.5 (27½ × 23½)
Tate

22
Robert Longo

Jules, Gretchen, Mark, State II 1982–3

Lithograph and embossing on paper
76.2 × 134
(30 × 52¾)
Tate

23
Robert Longo

Sword of the Pig 1983

Mixed media on wood relief, paper and aluminium
248 × 588 × 51
(97¾ × 231½ × 20)
Tate

In *Satori Three Inches within Your Heart* (fig.25), for example, a flat monochrome rendering nullifies the erotic potential of the central nude, while the yellow overlay distances us from any emotional impact that the social realist tableau at the top might have possessed in its original form. Only the cut melon has any real resonance, suggesting a displaced sexuality that can only be experienced through eroticised objects. Lawson, pointing to Salle as exhibit A in his quest to subvert painting from within, approvingly describes his works thus: 'They are dead, inert representations of the impossibility of passion in a culture that has institutionalised self expression.'

Though Salle and Longo continue to employ the discredited medium of paint, photographic reproductions are central to their work. Critical postmodernists take the mediation of reality as the central fact of contemporary life and they take photography as the central exemplar of mediation. Photography is quintessentially postmodern for a number of reasons. Because

any number of equally distinct prints can be made from a single photographic negative, there is no 'original', a condition that meshes perfectly with the postmodern negation of uniqueness and originality. Because photography, however manipulated, lies at the heart of most advertising and mass media, it provides the most pervasive conduit for ideology, making it ripe for deconstruction. And because photography is based on visual illusion – even the most abstract photograph is still a photograph of something – it wreaks havoc with Greenberg's efforts to remove all external reference from art. As a result, photography provides postmodernists both with the perfect tool and the perfect target. As Thomas Lawson maintains, 'The camera, in all its manifestations, is our god, dispensing what we mistakenly take to be truth. The Photograph is the modern world'.

Andy Warhol was arguably the first fully to recognise this fact, and his photobased works enshrine a version of reality that is composed entirely of

readymade images originally produced for the purposes of tabloid journalism, advertisement, promotion and entertainment (fig.26).

However, Warhol still renders his images in paint, letting the transition from photograph to silkscreened painting artfully confuse the distinction between mechanical reproduction and hand craftsmanship. In the terminology of Walter Benjamin's essay of 1936, 'The Work of Art in the Age of Mechanical Reproduction' (a work that serves as holy writ for many of the anti-aesthetes), his paintings still have 'aura', that ambiance of uniqueness that the multiply reproducible photograph can never achieve.

Subsequent artists working with photography went further, eliminating both the last vestiges of human touch and any reference to the original context from which the image has been torn. In the 1970s, John Baldessari turned from

24
James Rosenquist

Marilyn 1974

Lithograph on paper
90.5 × 69.5
(35¾ × 27½)
Tate

25
David Salle

Satori Three Inches within Your Heart 1988

Acrylic and oil on canvas
214.2 × 291
(84¼ × 114½)
Tate

painting to the creation of photomontages based on B-movie stills. He notes that he is not interested in the long-forgotten films from which they came, or even in any cultural messages they might convey. Instead, they operate as open-ended signifiers that can be shuffled in arbitrary ways to create new and unintended narratives. For instance, *Heel* (fig.27) is an assembly of various images that relate in one way or another to the word 'heel'. While some are literal representations of the bottom of feet, others take on more metaphoric associations – as the command for a dog to stop, for instance, or as unflattering slang for a man. Together, they invite the viewer to recompose them into any order that makes sense.

By contrast, Victor Burgin is interested in the social messages embedded in photographic images culled from Hollywood film or advertising. After isolating them from their sources, he provides new contexts that highlight the

unspoken assumptions they embody. *Lei-Feng* (fig.28) is composed of nine panels, each containing the same photographic image of a prosperous family celebrating a beautiful daughter's appearance on the cover of *Vogue* magazine. The original caption for this photograph, which was an advertisement for Bristol Cream sherry, read: 'Every bread winner deserves to be toasted.' Hence it associated its product with beauty, economic success and family harmony. Burgin has replaced this caption with a running narrative taken from a Maoist parable about a young soldier who learns that it is more important to perform the mundane tasks required by the community than to seek personal glory. In other words, its message, which stresses the sublimation of self for the sake of the collective, runs exactly counter to the celebration of individualism in the photo above. A third element is an academic commentary on the semiotic

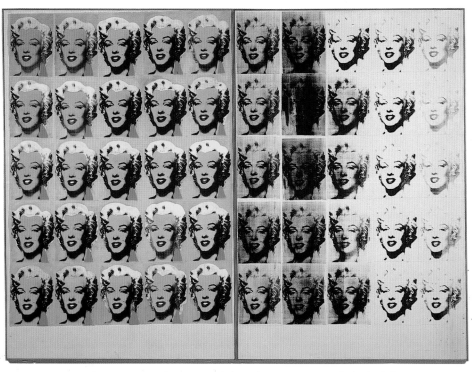

26
Andy Warhol

Marilyn Diptych 1962

Acrylic on canvas
2 panels, each
205.4 × 144.8
(81 × 57)
Tate

27
John Baldessari

Heel 1986

Black and white
photographs with oil
tint, oil stick, and
acrylic
270.5 × 220.9
(106½ × 87)
Los Angeles County
Museum of Art, Mode
and Contemporary Ar
Council. Gift of the
artist

relationship of text and image and the arbitrary nature of the link between signifier and sign. Taken together, the three apparently unrelated elements serve as a caution against uncritical consumption of any mass-culture representation.

Baldessari and Burgin purloin already existing images and recontextualise them in ways that leave plenty of room for viewer interpretation. But the more extreme formulations of postmodern theory would do away with the artist altogether and leave the task of constructing the meaning of a photographic image solely with the viewer.

The ultimate example of this is the work of Sherrie Levine. Levine ignited a minor controversy in the early 1980s with a series of photographs that were simply unretouched photographs of works by illustrious art photographers like Edward Weston and Walker Evans. From an old-fashioned perspective, these works were simply plagiarism. But in postmodernist terms they were the purest

examples of appropriation, which was shorthand for the widespread practice of plundering art-historical and mass-media images for use in contemporary artworks.

Levine carefully included the name of the original photographer in each work, titling them *After Walker Evans* or *After Edward Weston* (fig.29). She insisted these became new works through her act of claiming them. In this, she was echoing the assertions of the narrator of Jorge Luis Borges' story 'Pierre Menard, Author of *Don Quixote*' (1939), a droll conceit that briefly became required reading in art schools thanks to Levine's use of it to justify her attack on authorship. In Borges' story, a twentieth-century pedant named Pierre Menard struggles to recreate several chapters of Cervantes' *Don Quixote*, not by simply reading and transcribing them, or even by assuming, to the degree possible at a remove of four centuries, the identity of Cervantes. Rather, Menard resolved 'to go on being Pierre Menard and reach the Quixote through the experiences of Pierre Menard'. This is followed by a comical passage in which the reader is invited to read two identical passages from Cervantes' and Menard's *Quixote*. The narrator marvels at the greater subtlety of Menard's 'version', coming as it does from a twentieth-century writer who has had to arrive at an archaic style and mental state despite his knowledge of the intervening centuries. The point here is, of course, that the meaning of the book changes when the reader imagines a different author. Thus it presents a tongue-in-cheek illustration of Barthes notion that 'the birth of the reader must be at the cost of the death of the Author'.

Interestingly, Levine's jeremiad against originality was itself not original. After her radical gesture became cocktail-party chatter, commentators began circulating an essay originally published under the name Cheryl Bernstein in an anthology of Conceptual art entitled *Idea Art* in 1973. It purported to be a review of the one and only show of an artist named Hank Herron, who created exact copies of paintings by Frank Stella. In an analysis that struck a chord with the later generation, Bernstein averred, 'Mr Herron's work, by reproducing the exact appearance of Frank Stella's entire oeuvre, nevertheless introduces a new content and a new context ... that is precluded in the work of Mr. Stella, i.e. the denial of originality'. However, both Hank Herron and Cheryl Bernstein were the invention of a pseudonymous art historian and the essay itself was written as a parody of the logical consequences of Conceptualism. Ten years later, Conceptualist satire had become postmodern reality, and few who eagerly brandished the essay as support for the postmodern position realised that it was written as a joke.

Though Levine took postmodernism's most radical position on authorship, she was by no means alone. Richard Prince staked out a similar artistic territory by rephotographing images from magazines and advertisements. Echoing Barthes again, he remarked, 'I think the audience has always been the author of an artist's work. What's different now is that the artist can become the author of someone else's work'. (A few years later, the artist Jeff Koons would run into legal trouble with just such an attitude.)

Prince became particularly associated with fragmentary representations of images of the Marlboro Man of Marlboro cigarettes fame (fig.30). Removed

The semiotics of iconic signs confronts two basic questions which are so closely related as to be frequently confused. The one concerns the mechanics of denotation by which an iconic sign simultaneously presents and mediates its object. The other concerns the process in which the object is itself culturally constituted as a sign. The former is fundamentally a technical question which may be resolved in the areas where semiotics overlap such disciplines as psychology and mathematics. The latter is a social, ultimately ideological, question the answer to which seeks to give account of the articulations through which a culture presents reality.

The posing of the former, above, has ideological implications in common with the latter in that it emphasises that photography is a process of *production*. Such a process, through the technical manipulation of materials, mediates reality and constitutes an ideological intervention in the world. This awareness corrects the ingenuous acceptance of the camera as an incorruptible instrument of truth. We are thus returned to the question of the *motivation* of iconic signs. It is not arbitrary that a particular photographic image should have as its referent, say, 'woman wearing twin-set with silk scarf'. It *is* arbitrary however that this particular referent should have such an interpretant as 'bourgeoise'.

Iconic signs directly denote only objects in the physical world. It is only through these objects that images signify such abstract entities as values. Any study of the meanings of an iconic sign must therefore include consideration of the meanings of its object-as-sign. In fact, as Metz has observed, all systems of signification must converge on the same sphere. "All systems of signification, whatever they may be, have the function of transmitting sense. They may borrow their signifiers from very diverse spheres (visual, auditory, etc.) but their signifieds belong always to the semantic sphere and to it alone: to this ideal "purport" - immaterial purport, if one can call it that - to this psycho-sociological purport which is "sense".

"Did Zhang Si-de fall gloriously in front-line action?" asks the instructor. Lei-Feng replies that Zhang Si-de died in a coal-mining accident.

from his advertising context, the sturdy cowboy became a free-floating signifier of the mythology of American masculinity, with its emphasis on self-sufficiency and freedom from social constraints. Prince eliminated captions and presented only portions of the original images, often blown up so large that the ben-day dot pattern was visible. Thus the images became oddly oblique and dispassionate, revealing (or so commentators argued) the emptiness of the ethos of rugged individualism.

Prince's choice of the Marlboro Man resonated with the larger mythology of the Reagan era. These were the years, after all, in which the President of the United States was a former actor who frequently confused the heroic roles he had played in westerns and war movies with his own rather tame experiences during the Second World War.

30
Richard Prince

Untitled (cowboy)
1989

Ektacolor print
185.4 × 275
(73 × 108¼)
Courtesy of Barbara
Gladstone Gallery,
New York

The attacks by critical postmodernists on authorship and originality did nothing to cool the raging art market of the 1980s. Even if they had originally been designed to resist commodification, works by artists like Salle, Longo, Levine and Prince became hot commodities and sold just as well as the paintings of the unresistant Neo-expressionists. (The anti-aesthetes, incidentally, seemed disinclined to go all the way when it came to obliterating the myth of originality, and were frequently found on the pages of art magazines explicating the nuances of their particular brand of anti-authorship.)

The contradictions inherent in critical postmodernism became glaringly obvious as the decade wore on. As a result, they inspired a new group of artists to take the critical artists' simultaneous position of subversion and complicity as the subject of their work.

3

31
Andy Warhol

Brillo Box 1964

Synthetic polymer and
silkscreen on wood
43.2 × 43.2 × 35.6
(17 × 17 × 14)
Private Collection

COMMODITY CRITICS

Much to the dismay of the purveyors of anti-aestheticism, towards the end
of the 1980s their intricate arguments against authenticity, originality and
authorship were retooled to justify the return of the object. This was not,
however, the aestheticised art object valorised in modernist discourse. The
postmodern art object was decked out with a gleaming new theoretical raiment
and sparkled with impressively obscure terms like 'simulacrum', 'hyperreality',
'critical complicity' and 'commodity critique'.

Again, precedents were sought in art history, and again,
Duchamp and Warhol were dusted off as
spiritual ancestors. However, the
interpretations of these artists were subtly
different this time around. The anti-
aesthetes had been interested in the
negation of aesthetics implied by
Duchamp's famous presentation of an
ordinary urinal as a work of art. The
commodity critics believed that Duchamp's
gesture, rather than deflating high art, had
conferred Walter Benjamin's famous aura
upon a lowly implement of plumbing.
Similarly, the Warhol who interested this
new group was not the Warhol of appropriated
mass-culture images, but Warhol the creator of *Brillo Box*

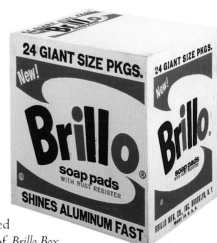

(fig.31), a carefully painted replica of the packing box for a ubiquitous cleaning product.

Interestingly, this is the same work that inspired Arthur Danto's epiphany about the end of art. For Danto, Warhol's *Brillo Box* was the end of the modernist line – art became self-conscious in a Hegelian way by raising the paramount question about its ontological status – why is this art and not simply a Brillo box? With *Brillo Box*, Danto believed, 'Art had raised, from within and in its definitive form, the question of the philosophical nature of art'. In other words, art had completed the line of questioning that had begun when photography stole its earlier justification as an imitation of reality. Now that the ultimate question had been asked, there was nothing more for art to do but splinter into different varieties of art-making – the pluralistic creation of hand-crafted objects that no longer asked philosophical questions.

If *Brillo Box* represented the end of modernism in Danto's schema, for the commodity critics it marked the beginning of postmodernism. For them, its key element was the recognition of the identity of artworks and consumer products. From this it was a short leap, via a particularly defeatist

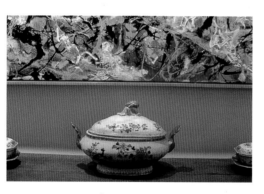

interpretation of poststructuralism, to the conclusion that we live in a soulless, empty society in which the selection of running shoes or table lamps has become the most complex form of self expression.

The new work elevated gleaming vacuum cleaners, lava lamps and 'surrogate paintings' to gallery status. In this, it bore some resemblance to Pop art. However, Pop art had proffered a buoyant vision of consumer culture as a garden of earthly delights. The commodity critics, by contrast, were mired in a technological dystopia in which people only sustain the illusion of individuality and choice by cultivating their relationship to mass-produced objects.

This work was, in part, a response to what the artists saw as the takeover of individual consciousness by mass media and advertising. They argued that late capitalism has created a 'spectacular' society in which the false excitement engendered by the consumption of mass-produced objects and images masks what they regarded as an all-powerful, amoral and inescapable economic system. Citizens had become consumers who elected politicians on the basis of media presence, and purchased products because they appealed to a media-constructed self-image.

Explanations of the art of commodity critique were infused with traces of Marxist rhetoric – especially references to Marx's notion of commodity fetishism, whereby objects divorced from the labour that created them become independent beings endowed with life. Mixed with poststructuralist ideas about the illusory nature of the self, free will and reality, this created a distorted, looking-glass Marxism. Bereft of a concept of the 'real', Marx's

32
Louise Lawler

Pollock and Tureen Arranged by Mr and Mrs Burton Tremaine, Connecticut 1984

Cibachrome
40.6 × 50.8 (16 × 20)
Courtesy of Metro Pictures, New York

33
Allan McCollum

Plaster Surrogates 1983

Enamel on solid-cast Hydrostone
Installation at Marian Goodman Gallery, New York 1983

economic base and dependent superstructure simply collapsed into each other. All that remained were empty signifiers of value and meaning which no longer belonged to any larger social or economic system. This created, in a terminology that became extremely fashionable during this period, the reign of the 'simulacra'. As a result, the literature about this new work is rife with statements that would be anathema to any orthodox Marxist. For instance, artist and writer Peter Halley's comment: 'Along with reality, politics is sort of an outdated notion', or the French theorist Jean Baudrillard's statement 'Power is no longer present except to conceal that there is none'.

The all-encompassing nature of the system envisioned by these artists led them to reject the anti-aesthetes' goal of resistance as vain and delusional. Instead, they embraced the media-generated desires that held them in thrall, acknowledging their own cheerful complicity in the wider dissemination of consumer culture. The market was no longer the enemy and the commodity status of art was a fact to be ironically celebrated.

The art created under this aegis took two different, though related, directions. It focused either on art as a commodity or on the commodity as art. The stage for the former had been set by the anti-aesthetes' campaign against the mystification of modernist art. Louise Lawler, more anti-aesthete than commodity critic, produced a series of photographs that showed artworks by modernist masters on display in collectors' homes (fig.32). Surrounded by expensive sideboards, ceramic pottery and other high-priced knick-knacks, modernist paintings created as expressions of high-flung individualism became mere collectibles, easily domesticated by the highest bidder.

Allan McCollum took the logic of Lawler's work the next step in his *Plaster Surrogates* (fig.33). These were intentionally 'fake' paintings – cast plaster objects shaped and painted to suggest little pictures with black rectangular interiors and white frames. Aside from the absence of a 'real' painting in the centre, these works had all the essential elements of a certified artwork: they were framed,

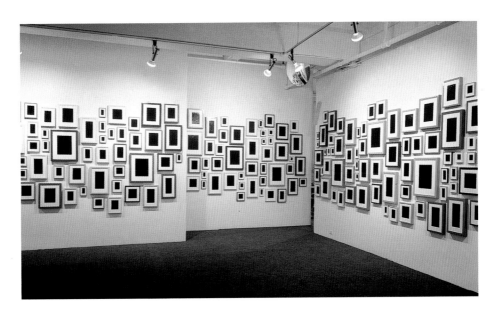

dated, numbered and signed by the artist and arranged on the wall in salon-style groupings. In effect, they operated like stage props, yet they sold like hot cakes during the late 1980s, demonstrating the artist's point that trappings alone could create a marketable work of art.

In their different ways, each of these artists suggested that modernist abstraction had been emptied of its utopian aspirations. No longer the outcome of historical necessity, abstraction became just another style to be peddled in the marketplace. This idea was graphically illustrated by the abstract paintings of Sherrie Levine, who seamlessly made the transition from

anti-aesthete to commodity critic. In the late 1980s, she presented a series of small geometric paintings that were appropriations, not of the specific style of any artist, but of the general appearance of geometric abstraction. Her grid compositions (fig.34) had a vague family resemblance to works by artists such as Kenneth Noland, John McLaughlin and Brice Marden, but the checkerboard format also gave a nod to Duchamp, the master chess player and art world strategist.

One of the points of Levine's new works, endlessly belaboured by sympathetic critics, was that they presented the idea of a copy without a model.

They cannibalised the look of modernist abstraction without grounding it in any specific historic moment or artist. This made them, in the lexicon of the day, 'simulations'. This term owes everything to Jean Baudrillard, who briefly became the guru of this new movement until he publicly disavowed the whole thing. According to Baudrillard, simulation is 'the generation by models of a real without origin or reality: a hyperreal'. In this new age of simulation, 'there is no longer any God to recognise his own, nor any last judgement to separate true from false, the real from its artificial resurrection, since everything is already dead and risen in advance'.

What exactly Baudrillard meant by such overheated rhetoric was never entirely clear, but for the artists who adopted him, he provided the map for a world in which reality had been replaced by signs and images. He bespoke the triumph of mass culture and consumer capitalism over any remaining vestige of genuine selfhood or authentic feeling.

No acolyte was more devoted to Baudrillard than Peter Halley, who laced his commentaries on contemporary art with endless references to hyperreality and the simulacrum. Halley painted geometric paintings of garishly coloured squares and rectangles connected with thick black lines. Like Levine, his work looked back to modernist predecessors, among them Piet Mondrian, Barnett Newman and Frank Stella. However, Halley had a more specific agenda. Decrying what he referred to as 'the geometricisation of modern life', he offered his paintings as visual maps of post-industrial society's networks of circulation and mechanistic movement. He believed he was describing a new, highly abstracted kind of social space, one akin, in his words 'to the simulated space of the videogame, of the microchip, and of the office tower'.

Thus, Halley intended the rectangles and the lines in his works to represent systems of cells and conduits which, he maintained, underlie all contemporary systems of social, political and economic exchange (fig.35). Interestingly, in describing these dematerialised networks of communication, Halley seems to

34
Sherrie Levine
Lead Check #10 1988
Casein on lead
50.8 × 50.8
(20 × 20)
Courtesy of Paula Cooper Gallery, New York

35
Peter Halley
White Cell with Conduit 1985
Day-glo acrylic and Roll-a-tex on canvas
213.4 × 106.7
(84 × 42)
Grant Selwyn Fine Art, New York and Los Angeles

have anticipated the widespread use of the internet by ten years. However, in his formulation, this development was anything but liberating. Rather, these all-encompassing cybernetic networks were the final triumph of 'late capitalism' (a term coined by Frederic Jameson) and technology over the human spirit. He muses, 'Yet behind the mask of humanism there exists not the truths of materialism but the nightmare scenarios of logic and determinism. There emerges a crystalline world responsive only to numerical imperatives, formal manipulation, and financial control'.

Halley painted with Day-glo paint over a textured surface produced by Roll-a-tex, a simulated stucco used on interior walls. Thus he piled simulation on simulation – in the process, transforming the signs of modernist abstraction into a postmodern exposition on the failure of all its ideals.

The other side of commodity critique was the assertion of the commodity as art. Again, simulation was an underlying theme, here creating not products that looked like old-fashioned art, but artworks that looked like commercial products. This approach had been anticipated, not only by Warhol's *Brillo Boxes*, but also by the work of Richard Artschwager, who in the 1960s married Minimalism and Pop to create furniture-like sculptures. In works such as *Table and Chair* (fig.36) he delineates the outlines of familiar pieces of domestic furniture on a pair of Minimalist forms, using wood-grain Formica as a veneer. In the terminology of the late 1980s, Artschwager's simulated furniture was created out of simulated material. He further undermined art's special status by pointing out that Formica is a material more often found in suburban bathrooms and kitchens.

Haim Steinbach went the next step, substituting for commodity-like

sculptures the commodities themselves. While his work owed a powerful debt to Duchamp's readymades, he was interested in a reverse operation. He sought not to deflate the pretensions of high art, but to glamorise the mass-produced object so that it could be appreciated from a purely aesthetic point of view.

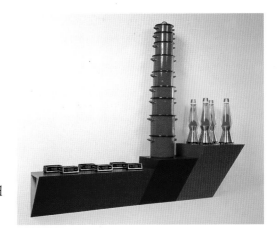

Steinbach placed newly purchased products on brightly painted Minimalist shelves that recalled the sculptures of Donald Judd (fig.37). He was particularly attracted to objects with a high kitsch component – *Star Wars* masks, designer toilet brushes and lava lamps – or which spoke of certain lifestyle expectations – colour-coordinated kitchen utensils, expensive running shoes and digital alarm clocks. Objects like these, he felt, were particularly imbued with the calculated seductiveness through which consumer desire is stimulated. His careful arrangements were designed to meld the ambiance of the art gallery with that of the department store in order to capture the peculiarly late twentieth-century fascination with consumer products. 'Ali Baba's cave is not unlike Macy's', he noted. In Steinbach's view, shopping had replaced art-making as the ultimate act of self-expression. He viewed the department store as the cathedral of postmodern desire and the act of shopping as the postmodern version of democratic choice.

Glamorised appliances and commodities reappeared in the work of Jeff Koons. He placed new, unused vacuum cleaners in Minimalist-style Plexiglas boxes. Hermetically sealed off from the corrupting environment, these works were intended to contrast the state of the object, forever new and immutable, with the constantly aging, mortal viewer. Koons followed these works with a series of *Equilibrium Tanks* (fig.38) in which basketballs inflated with water and mercury were unnaturally suspended in aquariums full of salt water. Again, Koons' point was that stasis and equilibrium are states reserved for inanimate objects. Thus, in works like these, he suggests that commodities are our more perfect selves, and that our desire for them is the desire for unsustainable states of being.

There is a whiff of the apocalypse in Koons' work, because, of course, the closest we living creatures can come to the stasis of commodities is death. This romance with nothingness is further articulated in the work of Ashley Bickerton. Bickerton first emerged in the late 1980s with hybrids of painting and sculpture that stressed their own objecthood. Resembling a strange cross between footlockers and pinball machines, these works exaggerated the physical attributes of artworks to the point of parody. They were boxes outfitted with large brackets for hanging, neatly stored packing materials, oversized handles, digital counters for recording the work's minute-by-minute price increases and lists of the materials that went into them and their toxic effects. Their surfaces

36
Richard Artschwager

Table and Chair
1963–4

Melamine laminate
and wood
75.7 × 132 × 95.2
(29¾ × 52 × 37½)
Tate

37
Haim Steinbach

Ultra-red 2 1986

Mixed media
construction
160.6 × 193
(63¼ × 76)
Courtesy of Sonnabend
Gallery, New York

38
Jeff Koons

*Three Ball Total
Equilibrium Tank (Two
Dr J Silver Series,
Spalding NBA Tip-Off)*
1985

Mixed media
153.6 × 123.8 × 33.6
(60½ × 48¾ × 13¼)
Tate

39
Ashley Bickerton

Biofragment #2 1990

Wood, anodised
aluminium, glass,
rubber, nylon and coral
294 × 213.6 × 113.8
(115¾ × 84× 44¾)
Tate, on loan from
The American Fund for
the Tate Gallery

were covered with real and invented corporate logos, slickly painted images that suggested unidentifiable machine parts and brightly painted plaster rocks. One work, identified as a self-portrait, was lined with labels from the products that the artist consumed on a regular basis.

Such works were graphic illustrations of the simulationist model of the disappearance of all distinctions between self and world, nature and culture, art and commodity, 'fake' and 'real'. In the early 1990s, Bickerton expanded on the ecological theme touched on in this earlier works. His boxy hanging sculptures turned into time capsules filled with agricultural substances and industrial waste. Entitled *Biofragments* (fig.39) they retained the emphasis on sturdy, industrial-looking casing, but now, Bickerton explained, tongue firmly in cheek, they were meant to be survival kits designed to outlast the upcoming nuclear or environmental holocaust, providing hapless survivors with the materials to start again.

Thus, with these works, Bickerton took the commodity critique's latent nihilism to its logical conclusion, envisioning a scenario in which the whole sorry structure of late capitalism was swept away to give humankind a chance to begin anew.

Having moved from the end of art to the end of civilisation, the commodity critics implicitly mocked any effort to deflect history from the inevitable apocalypse. By maintaining that left is right, right is left, truth is fiction and capital is beyond morality, the simulationist faith posed a world in which politics is a simulacrum and all meaningful action is impossible.

Needless to say, these views were not universally accepted, even among those who agreed with some aspects of their critique of mass media and consumer capitalism. Naysayers pointed out that, despite the efforts to reduce all human experience to a play of signifiers, something 'real' did seem to exist out there. Commodity critics could argue that nature was simply a cultural construct, that, in the words of critic and dealer Jeffrey Deitch, 'The jungle ride at Disney World may in fact be more real to most people than the real jungle in the Amazon'. They could say the same of the body, reducing consciousness to the model of the computer, in which the software is divorced in every substantial way from the hardware. Such clever formulations were easily refuted by the larger social and environmental issues of the day, among them AIDS, global warming and ecological devastation.

Other developments indicated that the dead end of commodity critique was not the only course for those of a deconstructive bent. The 1980s and 1990s also saw the burgeoning of a postmodern feminism and multiculturalism for which the analyses provided by poststructuralism offered tools for intervening in the power structures of the supposedly dear-departed 'real' world.

4

POSTMODERN FEMINISM

It is now time to introduce another term that is crucial to any discussion of postmodernism. This is the 'Other', a word that seems simple but is in fact heavily weighed down with conceptual and linguistic complexities. Like postmodernism itself, the Other is a thing that only exists in relation to something else. It has no independent essence. However, and this is where deconstruction comes back in, the apparent integrity of the Other's opposite (in other words, the thing that it is the other of) depends on the suppression of whatever contradictory material is designated as Other.

Thus, for example, Greenberg's modernism assumed the universality of its forms and its definition of art. However, this 'universality' left out the experiences and the creations of women, non-whites and non-Western cultures. Its status as the historically necessary next stage of art history depended on relegation of these elements to the margins.

The more socially oriented versions of postmodernism that we turn to next bring these Others back into focus. In doing so, they shatter the illusion of universality fostered by modernism. However, by its very nature, the Other cannot simply dethrone modernism, replacing one false universality with another. Rather, the Other must operate as a saboteur, continually undermining the effort to install any group or philosophy as the privileged purveyor of truth and reality.

Lest this be getting too esoteric, it may be easier to follow the logic of the argument through the evolution of feminism and multiculturalism, postmodernism's favourite Others. In this chapter, we will take up the former.

In 1971, art historian Linda Nochlin published a groundbreaking essay that asked, 'Why have there been no great women artists?' Nochlin's essay was designed not to confirm the dismal judgement suggested by the question but to challenge the assumptions about artistic genius that lay behind it. Rejecting the notion of art history as a parade of great artists, she chose instead to investigate the institutional, educational and economic factors that had prevented talented women from achieving the same stature as their male counterparts. Moving beyond the defensive stance implied by the question, Nochlin served notice that a feminist art history must ask new kinds of questions and reformulate the model for art-historical knowledge.

Other feminist art historians joined the cause. Some investigated forgotten figures, introducing a new roster of women artists into Western art history. Others extended into the psychological realm Nochlin's original study of the barriers faced by women, suggesting that a damaged ego might be just as powerful a drag on female creativity as such external limitations as lack of schooling and the demands of the domestic role.

By the 1980s, a second school of thought was emerging. This held that it was not enough simply to unearth forgotten women or recount the barriers they faced. Instead, feminist scholars like Griselda Pollock and Rozsika Parker argued that it was necessary to examine the rules by which the game is played. They noted that the language of art history – with its emphasis on gender-loaded words like 'mastery' and 'masterpiece' – is rife with hidden assumptions about the nature of genius. Similarly, they argued that the visual language of Western art embodies assumptions about the essential nature of femininity and masculinity. Why, feminist art historians began to ask, is the female nude the quintessential motif of post-Renaissance art? What messages are conveyed by all that nubile flesh served up as allegories of Virtue, Justice and Truth? Why are men and women represented so differently? In his book *Ways of Seeing* (1972) Marxist critic John Berger had one answer: in art, as in advertising, 'Men act and women appear. Men look at women. Women watch themselves being looked at'. Western art, in other words, replicates the unequal relationships already embedded in Western culture.

The evolution of feminist art follows a similar trajectory. In the 1970s, women artists began to explore the idea that there were essential differences in the experiences of men and women and that these could be discerned in their approach to art. Looking at the work being produced during this period by women artists, feminist critic Lucy Lippard discerned recurring motifs that she believed suggested a female sensibility. She pointed, for instance, to the abstracted sexuality inherent in circles, domes, eggs, spheres, boxes and biomorphic shapes. She noted a preoccupation with the body and body-like materials. She perceived a fragmentary, non-linear approach in the work of women that set it off from their male counterparts. She believed that such dissimilarities reflected the different way in which women organise their experience of the world.

In what has come to be known as First Wave Feminism, women artists immersed themselves in female experience – revelling in the hitherto forbidden territory represented by vaginal imagery and menstrual blood, posing

themselves naked as goddess figures, defiantly recuperating 'low' art forms like embroidery and ceramics, which had traditionally been dismissed as 'women's work'. They formed women's co-operative galleries, put together exhibitions of women's work, and generally saw their art as a form of feminist consciousness raising.

Again, there was a reaction. Absorbing the lessons of postmodernism, another group of feminist artists argued that First Wave Feminism was guilty of 'essentialism', that is, of perpetuating the futile search for female essence. Worse, they claimed to reach this essence by embracing the designations imposed on women by patriarchal culture – woman as nature, woman as body, woman as emotion – and changing them from negative to positive qualities.

By contrast, the postmodern feminists insisted that art should not try to provide positive images of female experience, as these inevitably ended up serving one ideology or another. Rather, they believed their job was to reveal the ways in which all our ideas of womanhood and femininity are socially constructed. They pursued the idea of femininity as a masquerade – that it is a set of poses adopted by women in order to conform to societal expectations about womanhood. They maintained that there is no female essence – rather, woman is only an internalised set of representations. This conformed to the general postmodern view of reality. As feminist theorist Kate Linker put it, 'Since reality can be known only through the forms that articulate it, there can be no reality outside of representation'.

In order to understand the process by which our visions of femininity are produced, feminist theorists turned to psychoanalysis. They were particularly taken with the writings of French psychoanalyst Jacques Lacan, who took Freud's theories about infant development and gave them a poststructural spin. According to Lacan, the unconscious is structured like a language. He rewrites Freud's pivotal Oedipal Complex in terms of the relationship between signs and signifiers. The father, who interrupts the infant's total identification with its mother, becomes in Lacan's scenario, the Name of the Father or the Law. He is the representative of the Symbolic order, the world of language that the child must enter to become a functioning member of society. But because language is always a matter of deferred meanings and of signifiers disconnected from their signs, the child gains language only to lose the sense of wholeness that he enjoyed in his pre-Oedipal state. Thus, humans are forever haunted by a sense of Lack, and long to repair the severed union with what the child once imagined to be his all-powerful mother. For Lacan, this Lack is the key to human psychology. It initiates a search for substitutes that might stand in for the lost, so-called Phallic Mother (an apparently contradictory notion that reflects the Lacanian transformation of the phallus from male organ to signifier of power). These substitutes, known as fetishes, are objects or images (or in poststructural terms, detached signifiers) on which the bereft individual fixates to alleviate an impossible desire.

It should not escape notice that this whole scenario focuses on the formation of male desire. This is where feminist theory steps in. In an enormously influential essay entitled 'Visual Pleasure and Narrative Cinema', theorist Laura Mulvey applies the notion of fetish to film theory. She argues

that Hollywood cinema is structured around the male gaze. It assumes the existence of a male spectator who transforms women into fetishes, either of the feared yet desired phallic mother lost after the intervention of the father, or of the castrated woman. This latter is an equally symbolic fixture whose diminished state reminds the man of the threat castration poses to his own power. Hence, she is the figure whom he must subjugate to regain his lost mastery over the world. In her analysis of classic films by directors like Hitchcock and von Sternberg, Mulvey notes how narratives, visual presentation and female characters are constructed to satisfy the male viewer's voyeuristic desires.

Mulvey ends her essay with the pronouncement: 'It is said that analysing pleasure, or beauty, destroys it. That is the intention of this essay.' Many feminist artists shared her discomfort with an aesthetic that linked visual pleasure with the objectification of women. And they found support in her essay for the idea that one could attack the unequal treatment of women in society by challenging the sexist representations of woman in art and the mass media.

However, as other feminists pointed out, there were limitations to such an approach. One had to do with its blind spot with respect to female psychology. Like the Freudian system on which it was based, Lacanian theory made male experience the centrepiece of the Oedipal drama. As a result, it had little to say about the psychic structures underlying female desire. In fact, at times the theory seemed to be positing desire as a purely male phenomenon. There was a male gaze, but evidently no complementary female gaze. Pleasure was bad because it reinforced male supremacy. But what about female pleasure? Was it really just a misguided identification with the male position?

At its extremes, postmodern feminism assumed a puritanical tone. First Wave Feminists who had celebrated female sexuality and publicly exposed their own, often voluptuous, naked bodies were criticised for playing into patriarchal power structures. Postmodern feminists seeking to destroy the aesthetic pleasure that satisfied men at the expense of women often pursued a form of iconoclasm, choosing to work with media images of women in a way that undercut their seductiveness. Or they opted to avoid representing the female body altogether on the theory that any form of representation perpetuates the objectification of women.

One of the most influential artists of this persuasion was Barbara Kruger. As an art director in the 1970s, Kruger worked on layouts for Condé Nast women's magazines. From this job, she learned both the graphic skills that she employed in her subsequent art work, and a sense of how magazines manipulate their readers through images. As she noted, 'It's the magazine's duty to make you their image of their own perfection'.

In her own art, Kruger juxtaposed texts and found or created photographic images in a way that subverted media conventions. Fragmented, lifted from their original contexts and reproduced in black and white, the images were open to new interpretations. These were supplied by the pithy texts slapped like advertising banners across the images. These texts assumed the authoritative tone of conventional advertising, but Kruger subtly manipulated the voice,

40
Barbara Kruger
Untitled (We Will No Longer Be Seen and Not Heard 1985

Nine colour lithographs with photo-lino and silkscreen, each 52 × 52 (20½ × 20½)
Tate

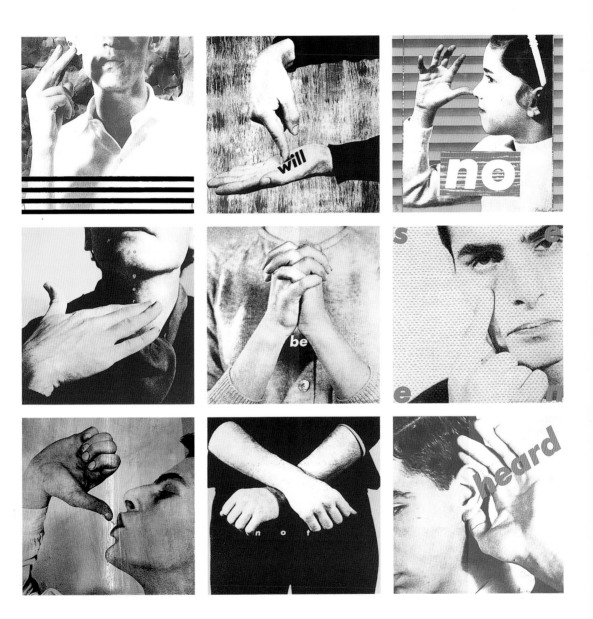

reversing the implied order in which the dominant male speaks to a submissive female. Here, the voice is that of woman addressing man about the conditions of her inequality, noting *Your Gaze Hits The Side Of My Face* or announcing *We Will No Longer Be Seen And Not Heard* (fig.40). In the latter work, Kruger has matched each word with its counterpart in deaf sign language, suggesting that, despite their suppression, women will find a language with which to communicate.

Sarah Charlesworth also mines the visual language of women's magazines. However, she retains the seductive gloss of fashion and advertising images. She subverts their original purpose by isolating details of glamorised objects against lustrous monochrome backgrounds, and surrounding the whole with black lacquer frames. Unlike Kruger, she supplies no words. Instead, combined

photo fragments – the head of a Japanese geisha, a lotus flower, a gold necklace, or as in *Figures* (fig.41) a disembodied evening gown and a bound figure completely encased in a bondage outfit, become free-floating fantasy images. They recall the Freudian concept of the fetish. However, while the Freudian fetish is embraced to restore a psychological wholeness, Charlesworth's fragmented, isolated images have the opposite effect, revealing the essential emptiness beneath the objects of male fantasy.

While Kruger and Charlesworth address themselves to the prerogatives of male power, Laurie Simmons explores the way in which media images shape the imagination of prepubescent girls. Her work plays off the role of dolls as surrogates through which young girls enact the shadowy rituals of adulthood.

By photographing cheap knock-offs of the ever-popular Barbie against photographic backdrops of domestic or travelogue settings, Simmons creates humorous tableaux that underscore the rigidity of traditional female roles (fig.42). Simmons' circa 1950 moulded plastic housewives and career girls pose stiffly against backgrounds which themselves evoke the picture-perfect world of that era's television and advertising. Yet the disjunction between the three-dimensional dolls and the obviously two-dimensional backgrounds make it clear that this is an unreal world, which they can never actually enter.

Female fantasy also plays a part in the work of Cindy Sherman, who has confessed that her staged photographs are inspired by her childhood game of dress up. In many ways, Sherman's work might seem to be a textbook illustration of Mulvey's notions about cinematic fetishism. Her *Untitled Film Stills* from 1978 are a set of black and white photographs in which Sherman has costumed herself to suggest the female types available in the Hollywood movies of her childhood. These range from femme fatale, rural naif, career girl, fallen woman (fig.43) to wide-eyed innocent. As the series title suggests, they were designed to suggest stills from 1950s-era B movies, and the illusion is so successful that some critics have been lured into describing their memories of the non-existent films from which these stills originated.

Sherman's *Film Stills* were embraced by feminist theorists who saw in it a brilliant exposition of the idea of femininity as masquerade. Noting the ease with which Sherman slipped from one fictive pose to another, never betraying any sense of essential selfhood, they hailed her work as a critique of the objectifying operations of the male gaze. Others put it in a media context, noting that her *Film Stills* demonstrate how our contemporary sense of self is a commercial creation subject to the whims of the film industry. And yet others took a more deconstructive stance, seeing in her work a representation of the postmodern world's decentred self, a fictional creature composed of fictions.

What all these interpretations had in common was a tendency to see Sherman as a stern polemicist taking on the evils of patriarchy, consumerism and late capitalist fragmentation. But they missed the obvious pleasure that Sherman took in making these images and which the spectator felt in viewing them. True, Sherman assumed a series of media-based roles, but she did so as

41
Sarah Charlesworth

Figures 1983

Laminated cibachrome
and lacquered frames
104.1 × 157.5
(41 × 62)
Courtesy of Gorney
Bravin + Lee, New York

42
Laurie Simmons

Red Library #2 1983

Colour photograph
123.2 × 97.2
(48½ × 38¼)
Courtesy of the artist
and Metro Pictures

a form of play, embracing the human capacity for fantasy without linking it to a negation of selfhood.

This has become ever more clear in Sherman's subsequent work, as she has explored the personas constructed in pornography, fairy tales, art history and fashion. Critical efforts to pin her to a politics of resistance are forever shattering in the face of the works themselves. For instance, in the mid-1980s, she produced several bodies of work dealing with the world of high fashion. Commissioned by top fashion designers to create advertising images from their clothes, she turned the conventions of fashion photography upside down (fig.44). Unglamorous, slightly sinister and even downright weird, her images could be seen as anti-fashion statements, revealing, as one critic put it, 'the monstrous otherness behind the cosmetic facade'. Yet they were embraced by the designers who commissioned them, suggesting that fashion may not be the uncompromising tool of patriarchy that some feminists have styled it.

43
Cindy Sherman
Untitled Film Still #27
1978
Photograph on paper
97.5 × 68.3
(38½ × 27)
Tate

44
Cindy Sherman
Untitled #126 1983
Photograph on paper
182.8 × 121.8
(72 × 48)
Tate

Sherman herself has always resisted the interpretations that pose her as a feminist ideologue. Thus, though the work seems at time to operate as a textbook case of certain strains of postmodernism, it eludes the more puritanical aspects of postmodern feminism. Her *Film Stills* can be read as critiques of the male gaze and the mass media's tendency to objectify women. But they also are permeated with Sherman's own enjoyment of the time-honoured adolescent girl's game of dress up. They are powerful reminders that there is a feminine form of pleasure that cannot be theorised out of existence.

Working in a very different mode, Mary Kelly also challenged the devaluation of female desire. Her *Post-Partum Document* (fig.45) is a six part, 135-piece document of the first six years of her son's life. It encompasses the minutiae of infanthood, incorporating diagrams, annotated letters, stained nappies, the child's drawings, feeding charts and analyses of the child's first utterances and sentences. But unlike the conventional scrapbook, Kelly's document interrogates the Lacanian account of the child's process of socialisation.

Kelly is aware of the Lacanian scenario in which the child moves from Imaginary wholeness to the sense of loss associated with the entry into the Symbolic. However, as she experiences the growth of her child first hand, she

becomes aware that something crucial is missing from Lacan's account – namely the reciprocal experience of the mother, and her side of the Oedipal drama. The woman is socialised into the role of mother just as the child is socialised into the outside world. And if the child learns to fetishise certain objects as substitutes for the once-seamless connection to its mother, so the mother also comes to embrace fetish objects that bring back her lost connection to the child, among them scraps of her son's clothing and plaster imprints of his hands. Thus, while Kelly reaffirms the postmodern belief that femininity, or in this case, motherhood, is socially constructed, she also reveals that it is a far more complex process than much theory would maintain. And she takes issue with the reductive formulations that would ascribe desire, pleasure and fetishism strictly to the male domain.

45
Mary Kelly

One of thirteen individually framed panels from

Post-Partum Document. Analysed Markings And Diary Perspective Schema (Experimentum Mentis III: Weaning from the Dyad) 1973

Collage, pencil, crayon, chalk, and printed diagrams on paper
Panel size 28.5 × 36 (11¼ × 14¼)
Tate

46
Gilbert and George

DEATH
from *DEATH HOPE LIFE FEAR* 1984

Handcoloured photograph, framed
42.2 × 25 (16¾ × 9¾)
Tate

The Lacanian account slights another area of human experience. The gaze it critiques is not just male, it is also resolutely heterosexual. During the 1980s, questions of alternative sexualities and homosexual desire began to surface within a population galvanised by the threat of AIDS. The same kind of discussions that had risen around female identity emerged among artists and theorists in the gay world. Again, much of the focus involved questions of representation and the possibility of a homosexual gaze.

Among the few highly visible practitioners of an unabashedly homoerotic sensibility prior to this period were the British duo Gilbert and George. They burst on the scene in the late 1960s with their 'singing sculpture', in which they posed as stilted bourgeois types awkwardly performing an old music-hall ditty. Later, they moved on to flamboyant photographic murals, which combined the radiant colours of stained-glass windows with provocative texts and images.

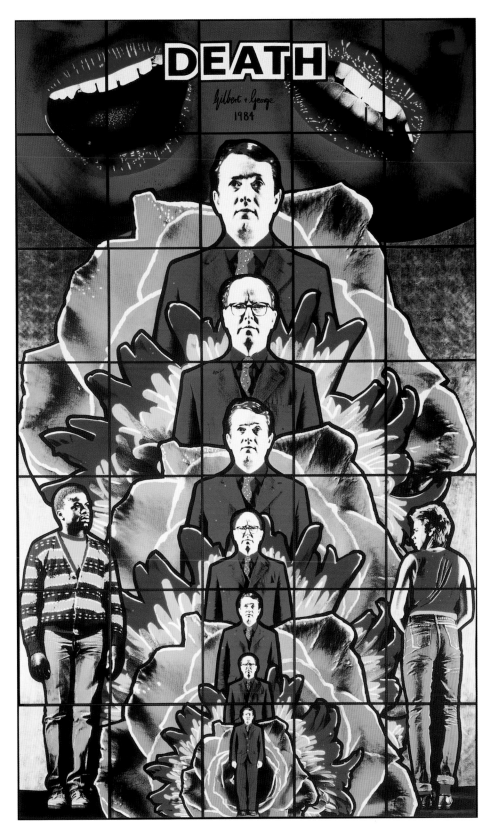

DEATH (fig.46), for instance, is one of a quartet of photo-pieces devoted to the eternal themes of Death, Hope, Life and Fear. The artists themselves appear repeatedly in their signature suits and ties, stiffly stacked in a column that rises from an open rose to a pair of yawning mouths. Their onward march toward mortality is observed by a pair of impassive working-class youths, a motif that recurs throughout their work as a symbol of erotic and perhaps unattainable desire.

Gilbert and George's buttoned-up personas seem to reflect a class-based, slightly repressed and deeply British form of homosexual sensibility. By contrast, the American artist Robert Mapplethorpe created highly charged, often shockingly explicit photographs exploring the sexual practices and fantasies of his gay subculture. Following Mapplethorpe's death in 1988, a posthumous exhibition of his photographs became a political fireball in the United States, as conservative Congressmen used them as proof that the

Federal Government, through the National Endowment for the Arts, was funding 'pornography'.

In fact, Mapplethorpe's figure photographs drew on traditions of high art photography and old master paintings to create seductive images whose sheer beauty served as a foil for their unrestrained sexuality. For instance, *Dennis Speight with Calla Lilies* (fig.47) makes obvious reference to the tradition of Renaissance religious art. However, Mapplethorpe makes explicit the erotic nature of the idealised bodies and seductive poses used to depict saints and sacred figures. Even more transgressive, the model here is a beautiful black man, suggesting that Mapplethorpe's sexual desires refuse to be confined by conventional barriers of gender or race.

As the 1980s wore on, the sterner definitions of postmodern feminism, with their iconoclasm, their emphasis on the intricacies of psychoanalytic theory and their discomfort with visual pleasure, began to seem counterproductive to feminist artists wishing to convey their message to a larger audience. While postmodern feminists may have analysed the nature of the problem, it began to seem to many women artists that this had done little to alter the situation of

women even in the realm closest to hand. When in 1984, the Museum of Modern Art in New York reopened after a renovation with an enormous exhibition billed as an 'International Survey of Recent Painting and Sculpture', the museum apparently saw no problem with presenting a roster of artists that was only 10 per cent female and 100 per cent white.

Coming in the middle of a decade that had centred on a male-dominated return to painting, this exhibition was the last straw for one group of women artists. They decided to form a guerrilla group that would take their case to the public at large. Dubbing themselves 'The Conscience of the Art World', the Guerrilla Girls donned gorilla masks and set about fly-posting messages on walls and buildings in New York's SoHo drawing attention to the dismal representation of women in the art world. They rated the critics according to their sensitivity to women, listed the galleries with the most and fewest women artists, and pointed out the absence of one-woman shows at the major museums.

These activities quickly earned the Guerrilla Girls media attention and soon they were appearing in their gorilla costumes on talk shows, at college campuses

47
Robert Mapplethorpe

Dennis Speight with Calla Lilies 1983

Cibachrome print 61× 50.8 (24 × 20) Copyright © The Estate of Robert Mapplethorpe. Used by permission

48
Guerrilla Girls

Do women have to be naked to get into the Met Museum? 1989

Offset printing on paper 28.1 × 71.2 (11 × 28) Spencer Museum of Art, The University of Kansas. Museum purchase: Lucy Shaw Schultz Fund

and in museum panels. They adopted many of the tactics of postmodernism, borrowing the street posters from Jenny Holzer, and adopting the media savvy of the Neo-expressionists and the faux advertising style of artists such as Barbara Kruger and Victor Burgin. But they also wore short skirts and high heels with their gorilla masks, and laced their posters and personal appearances with flashes of humour. Breaking away from the stridency of much postmodern feminism, they decided, as one member put it, to be 'sexy and funny'. As contributions poured in, they were able to produce more elaborate statements, including several billboards that made their point with playful wit (fig.48).

The Guerrilla Girls were of the postmodern era, but they were less interested in excavating the hidden structures of exclusion than in shaming the powers that be into bringing more women into the art establishment. They played with representations, but they wanted real results. In the latter part of their active years, which continued into the mid-1990s, the Guerrilla Girls began to broaden their agenda to deal with larger social issues, among them the art world's abysmal record of racial and ethnic inclusion. In this, feminism merged with the other great Other of postmodernism, which came to be referred to as 'multiculturalism'.

5

POSTMODERN MULTICULTURALISM

According to feminist and multiculturalist analysis, the notion of the Other inevitably implies a hierarchy. To be Other is to be considered less than the male and less than the individual of white European heritage. The Other is viewed as marginal, a sideshow in the grand narrative of world history.

Postmodern feminists attack this assumption by seeking the origin of their Otherness in human development. By using the tools of psychoanalysis, they expose the way in which the self is constructed to reinforce this sense of female inferiority.

Postmodern multiculturalists take a different tack. They seek the origin of racial and ethnic Otherness in the way in which history is constructed. They point to the distortions created by modernism, which envisioned history as a linear development towards universally embraced social, political and philosophical goals. These goals, set out by thinkers of the Enlightenment, involve the rule of reason, the universal establishment of democracy and the unfettered progress of science and technology. Such ideals, they note, were believed to be most thoroughly embodied in the histories of Western nations. Thus, modernist history justified the European colonialisation of Africa, Asia and North and South America as 'the White Man's Burden', invoking their moral imperative to introduce more 'primitive' cultures to the benefits of European civilisation.

In this schema, the histories of non-white and non-Western cultures were only of interest to the extent that they threw light on the larger course of Western history. The least technologically advanced societies were viewed as

Jaguar
a breed apart

Photo: Leyland

An employee may have an incentive to remain with his employer, no matter how he is treated, in order to qualify for urban residence; and it has been argued that contract workers' rights to work in urban areas are so tenuous that, regardless of how uncongenial their employment or how poor their pay, they are forced to stay in their job for fear of being endorsed out of their area and back to the homelands.

UK Parliamentary Select Committee on African Wages. 1973

 Leyland Vehicles. Nothing can stop us now.

Leyland advertising slogan

time capsules, pockets of arrested history where 'civilised' man could literally view his own past. A corollary to this was the idea that preliterate societies had no records of their own, and existed in a timeless present until forced into history by the onslaught of Western modernity. Modernism in art (or at least the Greenbergian version we are considering here), reflected many of these assumptions. It upheld a universal standard of taste, judged artworks as they reflected the historically necessary progress of art, and adhered to a canon that was almost exclusively white, male and American or European.

By 1984, the modernist facade was crumbling against attacks on all sides. Yet, even at this late date, it was still possible to mount an exhibition that viewed African art solely in its role as inspiration for the geniuses of Western modernism. *'Primitivism' in 20th Century Art* (the quotation marks are part of the original title, signifying a few qualms about the historical assumptions the term embodies), was mounted by the Museum of Modern Art in New York. It was designed to show how an exposure to African art in the collections of Paris museums had a crucial impact on the early modernism of artists such as Picasso, Miró and Giacometti.

If the exhibition had rested there, it would have been a fine example of art-historical research. However, the organisers went further, suggesting that there were universally discernable 'affinities' between the 'primitive' and modern works, and that it was through harnessing the wild irrationality of African art that modernist artists were able to reinvent Western art.

Critics savaged the exhibition, arguing that the notion of affinity ignored the very different functions and meanings that the African works carried in their original contexts. They noted that 'Art', the idea of objects created simply for aesthetic delectation, was completely foreign to the cultures that had created these objects. They pointed out that, while the Western paintings and sculptures were carefully labelled with the artists' names and dates, the African works were treated as anonymous, timeless creations to which any notions of attribution and historical dating were irrelevant. They condemned the exhibition's 'eurocentric' bias and called for a different approach to art outside the Western tradition. The reaction against the show marked a turning point in the art world's awareness of the Other. Critics, curators and artists began to espouse the ideal of multiculturalism as opposed to modernism's exhausted mono-culturalism. Like feminism, such explorations assumed a variety of forms. One of the most pervasive paralleled feminist essentialism, and sought from art authentic expressions of racial and ethnic identity. Artists from non-white or non-Western backgrounds searched for native traditions that had resisted the homogenisation of modernism. They created works based on native crafts, mythology, folklore and natural materials. Meanwhile, scholars began to rewrite the history of art to include cultures that had been deliberately excluded. Some went so far as to completely invert the familiar historical narrative by suggesting that in fact, Africa or India were the original sources of Western culture.

However, in the scramble for usable traditions, some strange things began to happen. It appeared that only certain traditions and approaches to art were culturally correct. Underlying the fascination with multiculturalism was the

tendency to equate the modern with the Western and to deliberately avoid expressions associated with either. As artists came to be categorised by race, ethnicity, gender and sexuality, an unspoken demand arose that they must speak for their group and for a certain vision of anti-modernism. But as critics of multiculturalism were quick to point out, these expectations merely reinforced the differences that modernism had asserted to justify the West's dominant position. Like the essentialist position that embraced women's designation as representative of nature, emotion and body, multiculturalism appeared to accept non-Western cultures as purveyors of spirituality, instinct and the irrational.

There were other difficulties. The search for authentic identity ignored the realities of migration and immigration. Was an artist of African descent whose family had lived in Britain or the United States for four generations closer to his African heritage or his Western one? Where was an artist of multiple ethnicities to turn for her identity?

In response to such questions, writers such as Thomas McEvilley and Cornal West proposed a different version of multiculturalism. They argued that the key issue was not identity, but representation. In a world where images govern reality, the important questions were: who represents whom? How and why are images of the Other created? Can marginal groups regain control of their own representations?

White artists resolved to refrain from any attempt to picture the Other, assuming instead the task of analysing their own privileged positions and the structures that upheld them. Such investigations were designed to reveal the architecture of an invisible system of oppression.

Hans Haacke, for instance, is a German-born artist who has made a career of exposing the hidden ties between economics, politics and aesthetics. *A Breed Apart* (fig.49) is typical of his concerns. Here, he creates a mock advertising campaign to suggest how Leyland Vehicles, a British-based automobile manufacturer, was able to elude the economic boycott of South Africa, thereby profiting from apartheid while claiming to be operating in the public good. A set of seven panels mixes slick promotional texts and images with information on the real conditions of apartheid. Photographs of sleek Leyland cars are played against images of South African military forces using Leyland vehicles to subdue South African rebels. The complex interplay of different kinds of information reveals how corporate collusion helped keep the apartheid government in power.

In a similar spirit, Krysztof Wodiczko, a refugee from Communist Poland, creates work that suggests a relationship between Communism's totalitarian rhetoric and the authoritarian messages that emanate from the US Government and corporate America. He presents his case by projecting huge photographic images on corporate and public buildings. These introduce reminders of realities that the proprietors of these buildings may wish to suppress – for instance, hands gripping bars on the otherwise anonymous facade of a federal prison, or for a brief, unauthorised moment during the apartheid era, a Nazi swastika on the South African embassy in London.

In *WORK* (fig.50), which appeared on the facade of the Hirshhorn Museum

50
Krzysztof Wodiczko

WORK from *Public Projections* 1988

Projection onto the Hirshhorn Museum, Washington DC
Courtesy of Hirshhorn Museum and Sculpture Garden, Smithsonian Museum
Photography by Lee Stalsworth

in Washington DC, Wodiczko revealed how race had been injected into the 1988 Presidential Campaign. Republican political advertisements had relentlessly focused on the release of a notorious black convict during the Democratic candidate's tenure as governor of Massachusetts. Playing on racial fears, the implication of the advertisements was that a 'liberal' Democratic administration would be overly sympathetic to blacks and hence dangerously lax on crime. Wodiczko's projection transformed the facade of the museum into a speaker's platform, in which the alternating rhetorics of hope and fear were symbolised by a hand holding a candle and a hand brandishing a revolver.

Haacke and Wodiczko suggest how oppressive hierarchies are kept in place through systems of public address controlled by government or corporations. Postmodern artists from non-white and non-Western backgrounds also borrow the language of public address to suggest how the experience of Otherness feels from the inside. Native American artist Edgar Heap of Birds uses the format of the road sign to remind us that history is written by the winners. *Native Hosts* (fig.51) revives the forgotten history of New York, welcoming its present inhabitants in the name of the Indian tribes whom they have so completely replaced. Chilean artist Alfredo Jaar similarly challenges assumptions of universality by programming the electronic signboard over Times Square with a map of the United States and the message 'This is not

America' (fig.52). His point, of course, is that the casual identification of the label 'America' with the United States effectively obliterates the existence of the other nations that inhabit the North and South American continents.

Other non-white artists address the stereotypes that determine white responses to them. Lorna Simpson focuses on the way in which being a black woman gives her a double invisibility. In *Guarded Conditions* (fig.53), she lines up a set of identical images of a black woman photographed from the back, her hands gripped behind her in a defensive gesture. Her double vulnerability is emphasised in a text composed of the repeated phrases 'sex attacks', 'skin attacks'. Meanwhile, Adrian Piper confronts what she regards as the sublimated racism of white society. In the video *Cornered* (fig.54), she speaks directly to the viewer across a barricade created by an upended table. In measured tones she reveals that, despite her light complexion, she is actually black, and challenges viewers to consider how that affects their response:

I'm black ... If I don't tell you who I am, I have to pass for white. And why should I have to do that? ... The problem is not simply my personal one, about my racial identity. It's also your problem if you have a tendency to behave in a derogatory or insensitive manner toward blacks when you see none present ... Some researchers estimate that almost all purportedly white Americans have between 5 per cent and 20 per cent black ancestry. Now, this country's entrenched conventions classify a person as black if they have any black ancestry. So most purportedly white Americans are, in fact, black ... What are you going to do about it?

51
Edgar Heap of Birds

Native Hosts 1988

Six aluminium signs
each 45.7 × 91.4
(18 × 36)
City Hall Park, New York
Courtesy of Public Art
Fund, New York

52
Alfredo Jaar

A Logo for America from
Messages to the Public
1987

Spectracolor
Lightboard, Times
Square, New York
Courtesy of Public Art
Fund, New York

If most whites are actually black, Piper suggests, their assumption of superiority is groundless.

By focusing on representation rather than identity, postmodern multi-culturalists find themselves wrestling with a different set of questions. Can a member of the dominant group represent the marginal group, or only analyse himself? Can a member of a marginal group speak for herself, or have her responses been too contaminated by the ruling ideology? Do restrictions on who can speak for whom ultimately lead to a situation in which no one can speak for anyone?

A further problem was raised by a controversial exhibition mounted by the Whitney Museum in 1994. Entitled *Black Male*, it was designed to investigate, not the reality of black maleness in America, but the nature of the representations that govern public perceptions of it. As a result, the works

in the show, largely but not exclusively created by black male artists, revolved mainly around negative stereotypes. For instance, Carl Pope's *Some of the Greatest Hits of the New York City Police Department* (fig.55) focused on police violence and the white public's perception of the criminality of young black men. Pope's installation consisted of a set of sportsman's trophies, each labelled with the names and dates of death of young black men killed by New York City Police. Robert Colescott's *George Washington Carver Crossing the Delaware* (fig.56) reinvents an iconic American history painting by substituting the black inventor George Washington Carver for the founding father George Washington. In Colescott's version, the black characters are realised as degrading cartoons, which humorously challenge white viewers to question how heroism is

represented in history. Fred Wilson's *Guarded View* (fig.57) presented a set of headless black mannequins in the garb of museum guards. Devoid of individuality or even humanity, they represent, Wilson suggests, the most common image of the black man to be found in a contemporary art museum.

While *Black Male* drew large audiences, critics on both sides of the political spectrum questioned its exclusive focus on negative stereotypes. Black men, seen through the eyes of white society, were thugs, criminals, victims, fools and menial workers. While the show intended to deconstruct and discredit these images, the absence of any alternative view brought it close to reinforcing the racist clichés it was meant to dispel.

Thus postmodern multiculturalism butts up against some of the same

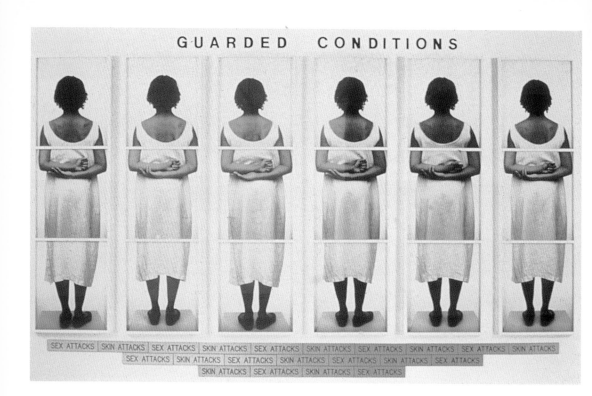

difficulties that beset postmodern feminism. An exclusive focus on representation offers little in the way of a map for positive change. At its most extreme, it suggests that giant walls separate Whites and Others in a world divided into oppressors and victims.

However, a more nuanced view is possible. One voice of moderation is provided by James Clifford, an ethnographer who rejects the isolationism inherent in both versions of multiculturalism. While he agrees that the search for authentic identity is a futile goal, he argues that the idea of authenticity itself need not be abandoned. Instead, he proposes that authenticity be reconceived as an ongoing creative activity in which elements of 'traditional' and 'modern' cultures collide, meld and restructure themselves into something new. More optimistic than the standard scenario of ruthless coloniser and helpless victim, this view has spurred an interest in hybridity –

the idea of cultures and individual identities continually being remade through their contact with each other.

One can see how this might work with artists who straddle the local and international. Japanese artist Yasumasa Morimura has been referred to as the Japanese Cindy Sherman, but his work has more to do with subtle interplays between the erotic fantasies of East and West. Morimura poses himself in tableaux drawn from Western art history or Hollywood publicity photos. With few exceptions, he makes himself up as a beautiful female, taking on roles like Marilyn Monroe, Ingres' odalisques or, as here, Manet's Olympia (fig.58).

In part, Morimura's work is a reminder that Western fantasies have traditionally placed Asians in a female, and hence subject position – Madame Butterfly, the exotic but discardable concubine, being the archetypal model. Here, a Japanese male overtly assumes this 'feminised' role. But more is going on than simple critique. Morimura lets us feel the pleasure he experiences in

submitting to this fantasy, and in turn the lushness of the photograph invites us to share his pleasure. For the Western viewer there is a discomfiture that derives from the model's obviously dissonant gender and race. 'Our' traditions have been absorbed and remade for another's purposes.

Something similar happens in the work of Chinese artist Wang Guangyi. In a style known in China as 'Political Pop', he melds the surprisingly similar languages of Communist propaganda and Western advertising to suggest that their ends also are also compatible. His works reflect the realities of China's post Tiananmen Square society, where making money has overshadowed all

GEORGE WASHINGTON CARVER CROSSING THE DELAWARE

other pursuits. In keeping with this new order, in Wang's *Great Castigation Series: Coca Cola* (fig.59), stalwart worker heroes of the Cultural Revolution find themselves promoting an American soft drink.

In works like these, representations become raw materials for transformations and new kinds of meaning. No longer the prison that confine us, nor the subtle instrument of an oppressive ideology, the representation becomes an elastic marker that maps out new possibilities. Thus, Clifford's hybridity takes us on beyond postmodernism to a world remade by globalism. But that's another story.

56
Robert Colescott

*George Washington
Carver Crossing the
Delaware: Page from
American History* 1975

Acrylic on canvas
213.4 × 274.3
(84 × 108)
Private collection.
Courtesy of Phyllis Kind
Gallery, New York

57
Fred Wilson

Guarded View 1991

Wood, paint, steel and
fabric
Dimensions variable
Whitney Museum of
American Art, New York.
Gift of the Peter Norton
Family Foundation

58
Yasumasa Morimura

Portrait (Futago) 1988

Colour photograph
210.2 × 299.7
(82¾ × 118)
Courtesy of Luhring
Augustine, New York

6

59
Wang Guangyi

*Great Castration Series:
Coca Cola* 1991–4

Oil on canvas
78¾ × 78¾
(200 × 200)
Private collection

Conclusion

In its heyday, postmodernism provided a much-needed corrective to the exclusionary and falsely universal world view of Greenberg-style modernism. But it also set in motion a series of negations that ultimately led to unacceptable consequences. At its most radical, postmodernism espoused a relativistic view of history that makes it impossible to refute absurd and dangerous ideas like Holocaust revisionism, recovered memory and alien abduction. Its obsession with representation led to an embrace of media that does nothing to counter the narcotic effect of film and tele-vision on the public at large. Its reduction of politics to a game of shifting signifiers displaced political activism from the streets to the ivory tower. And finally, the fashionable denunciations of the commodification of art, far from leading to the withering away of the art object, coincided with the most heated art market in history. Have we reached the post-postmodern era? There is evidence everywhere of the return of the real. Art today is full of celebrations of the body, nature, tradition, religion, beauty and the self. Plenitude has returned. Modernism, or at least modernisms, are back in vogue. Meanwhile, even the most ardent advocates of postmodernism have been forced to admit that the term has become discredited by its very popularity. As erstwhile postmodernist Hal Foster remarked recently, 'We did not lose. In a sense a worse thing happened: treated as a fashion, postmodernism became démodé'. But a close look reveals that the landscape has subtly changed. The real has returned in forms that reveal a shift of consciousness enacted by postmodernism. It is no longer possible to imagine that history takes a single course, or that the reader is not an essential component of any text, or that our sense of self is not deeply implicated in relationships of power and authority. For all its contradictions and occasional absurdities, it is clear that postmodernism has remade the world in ways that can never be retracted.

BIBLIOGRAPHY

Sources of quotations and further reading

Barthes, Roland, *Image-Music-Text*, trans. Stephen Heath, New York, 1977

Baudrillard, Jean, *Simulations*, trans. Paul Foss, Paul Patton and Philip Beitchman, New York, 1983

Benjamin, Walter, *Illuminations*, trans. Harry Zohn, New York, 1969

Bernstein, Cheryl, 'The Fake as More', in *Idea Art*, ed. Gregory Battock, New York, 1973, pp.41–5

Berger, John, *Ways of Seeing*, London 1972

Borges, Jorge Luis, 'Pierre Menard, Author of *Don Quixote*', in *Labyrinths: Selected Stories and Other Writings*, trans. Donald A. Yates and James Irby, New York 1964, pp.36–44

Buchloh, Benjamin, 'Figures of Authority, Ciphers of Regression', *October*, no.16, Spring 1981, pp.39–68

Burgin, Victor, *The End of Art Theory: Criticism and Postmodernity*, London, 1986

Clifford, James, *The Predicament of Culture*, Cambridge, MA, 1988

Danto, Arthur, 'Approaching the End of Art', in *The State of the Art*, New York, 1987

Deitch, Jeffrey, 'Artificial Nature' in *Artificial Desire*, exh. cat., Deste Foundation for Contemporary Art, Athens 1991

Fineberg, Jonathan, *Art Since 1940: Strategies of Being*, Englewood Cliffs, NJ, 1995

Foster, Hal (ed.), *The Anti-Aesthetic: Essays on Postmodern Culture*, Port Townsend, WA, 1983

Foster, Hal, *Recodings: Art, Spectacle, Cultural Politics*, Port Townsend, WA, 1985

Foster, Hal, *The Return of the Real: The Avant-Garde at the End of the Century*, Cambridge, MA, 1996

Halley, Peter, *Collected Essays 1981–87*, Zurich, 1988

Jameson, Frederic, 'Postmodernism and Consumer Society' in Foster, *The Anti-Aesthetic*, 1983

Jencks, Charles, *What is Post-Modernism?*, London, 1986

Kuhn, Thomas S., *The Structure of Scientific Revolutions*, Chicago, 1962

Kuspit, Donald, 'Flak from the "Radicals": The American Case against Current German Painting', in Jack Cowart (ed.), *Expressions: New Art from Germany*, St Louis Art Museum, 1983, reprinted in Wallis, *Art After Modernism: Rethinking Representation*, 1984, pp.137–51

Lacan, Jacques, *The Four Fundamental Concepts of Psycho-analysis*, ed. Jacques-Alain Miller, trans. Alan Sheridan, New York, 1978

Lawson, Thomas, 'Last Exit: Painting', *Artforum*, Oct. 1981, pp.40–7

Linker, Kate, 'Representation and Sexuality', *Parachute*, no.32, Fall 1983, reprinted in Wallis, *Art After Modernism: Rethinking Representation*, 1984, pp.391–416

Lippard, Lucy, *Mixed Blessings: New Art in a Multicultural America*, New York, 1990

Lyotard, Jean-François, *The Postmodern Condition: A Report on Knowlege*, trans. Geoff Bennington and Brian Massumi, Minneapolis, 1984

Mariani, Carlo Maria, quoted in Nairne, *State of the Art*, 1987, pp.27–30

Mulvey, Laura, 'Visual Pleasure and Narrative Cinema', in *Screen*, Autumn 1975, vol.16, no.3, pp.6–18; reworked version in *The Sexual Subject: A Screen Reader in Sexuality*, London and New York, 1992

Nairne, Sandy, in collaboration with Geoff Dunlop and John Wyver, *State of the Art: Ideas and Images in the 1980s*, London, 1987

Nochlin, Linda, 'Why Have There Been No Great Women Artists?', *Art News*, vol.69, no.9, Jan. 1971, pp.22–39, 67–71

Pollock, Griselda, *Vision & Difference: Femininity, Feminism and the Histories of Art*, London, 1988

Sandler, Irving, *Art of the Postmodern Era: From the Late 1960s to the Early 1990s*, New York, 1996

Saussure, Ferdinand de, *Course in General Linguistics*, trans. Wade Baskin, New York, 1966

Steinbach, Haim, statements from 'From Criticism to Complicity', roundtable discussion moderated by Peter Nagy, *Flash Art*, Summer 1986, p.46

Toynbee, Arnold, *A Study in History*, written 1938, pub. 1947, quoted in Charles Jencks, *What is Postmodernism?*, London, 1986

Wallis, Brian (ed.), *Art After Modernism: Rethinking Representation*, New York/Boston, 1984

INDEX

PHOTOGRAPHIC CREDITS

COPYRIGHT CREDITS